PAINT CHARMING SEASIDE SCENES WITH ACRYLICS

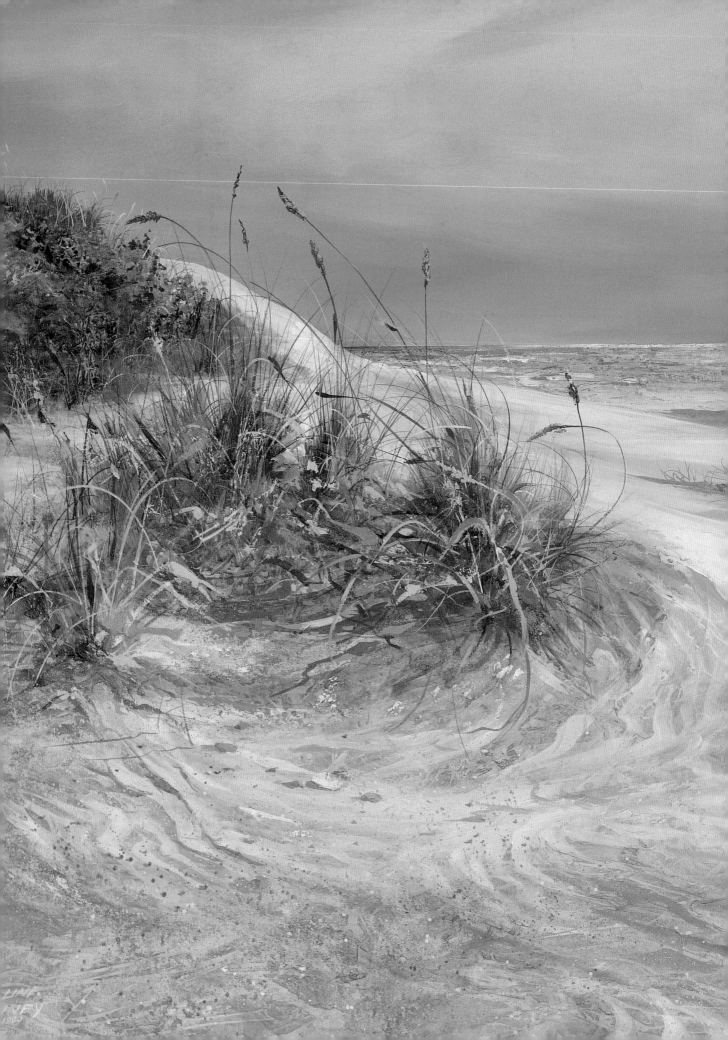

Paint
Charming
Seaside
Scenes
with Acrylics

Jacqueline Penney

NORTH LIGHT BOOKS
CINCINNATI, OHIO
www.artistsnetwork.com

ABOUT THE AUTHOR

Jacqueline Penney is a native of Long Island, New York. She won a scholarship to the Phoenix School of Design in New York City, where she received an excellent background in drawing and anatomy. After attending Black Mountain College in Asheville, North Carolina, and the Institute of Design in Chicago, Illinois, she continued her art education by studying with well-known artists around the country. She is listed in *Who's Who, Who's Who of American Women/Teachers*, and is widely published. Over one hundred of her paintings have been reproduced by Bentley Publishing Group of California.

Penney has been teaching for over thirty years and now shares her extensive knowledge and techniques in book form. *Painting Greeting Cards in Watercolor* (North Light Books, 1997) is an illustrated guide to making small works of art at home or on the go, and *Discover the Joy of Acrylic Painting* (North Light Books, 2001) extols the versatility of acrylic paints.

Penney is best known for her realistic pastoral scenes and seascapes, predominantly painted with acrylics, but she is adept in several other mediums. She currently resides on Long Island in the small North Fork community of Cutchogue, where she has renovated an 1840 barn into a distinctive home, gallery and studio. Visit her website at www.jacquelinepenney.net to see her prints, giclées and original paintings.

Published by North Light Books, an imprint of F+W Publications, Inc., 4700 East Galbraith Road, Cincinnati, Ohio, 45236. (800) 289-0963. First Edition.

fw
F+W PUBLICATIONS, INC.

Other fine North Light Books are available from your local bookstore, art supply store, online supplier or visit our website at www.fwpublications.com.

12 11 10 09 08 5 4 3 2 1

DISTRIBUTED IN CANADA BY FRASER DIRECT
100 Armstrong Avenue
Georgetown, ON, Canada L7G 5S4
Tel: (905) 877-4411

DISTRIBUTED IN THE U.K. AND EUROPE BY DAVID & CHARLES
Brunel House, Newton Abbot, Devon, TQ12 4PU, England
Tel: (+44) 1626 323200, Fax: (+44) 1626 323319
Email: postmaster@davidandcharles.co.uk

DISTRIBUTED IN AUSTRALIA BY CAPRICORN LINK
P.O. Box 704, S. Windsor NSW, 2756 Australia
Tel: (02) 4577-3555

Library of Congress Cataloging-in-Publication Data
Penney, Jacqueline
 Paint charming seaside scenes with acrylics / Jacqueline Penney.
-- 1st ed.
 p. cm.
 Includes index.
 ISBN 978-1-60061-059-2 (pbk. : alk. paper)
 1. Marine painting--Technique. 2. Acrylic painting--Technique. I. Title.
 ND1370.P46 2008
 751.4'26--dc22
 2008033029

Edited by Jeffrey Blocksidge
Production edited by Erika O'Connell
Cover designed by Kelly Piller
Interior designed by Wendy Dunning
Interior layout by Kim Pieper
Production coordinated by Matt Wagner

Metric Conversion Chart

To convert	to	multiply by
Inches	Centimeters	2.54
Centimeters	Inches	0.4
Feet	Centimeters	30.5
Centimeters	Feet	0.03
Yards	Meters	0.9
Meters	Yards	1.1

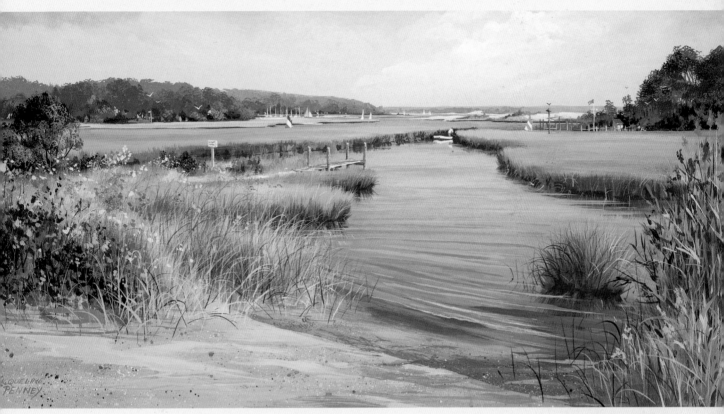

CHANGING TIDES
22" × 28" (56cm × 71cm)
Acrylic on canvas
Collection of Arthur Axberg

ACKNOWLEDGMENTS

I would like to thank Pam Wissman for inviting me to write this book, Jeffrey Blocksidge and Erika O'Connell for doing such a good job of editing, and Kelly Piller, Wendy Dunning and Kim Pieper for their excellent and thoughtful design.

DEDICATION

I dedicate this book to Roy DeMeo, a man of many talents. He is an artist, photographer, woodworker, teacher and an active member of the U. S. Coast Guard Auxiliary. But best of all, he is a very dear friend.

TABLE OF CONTENTS

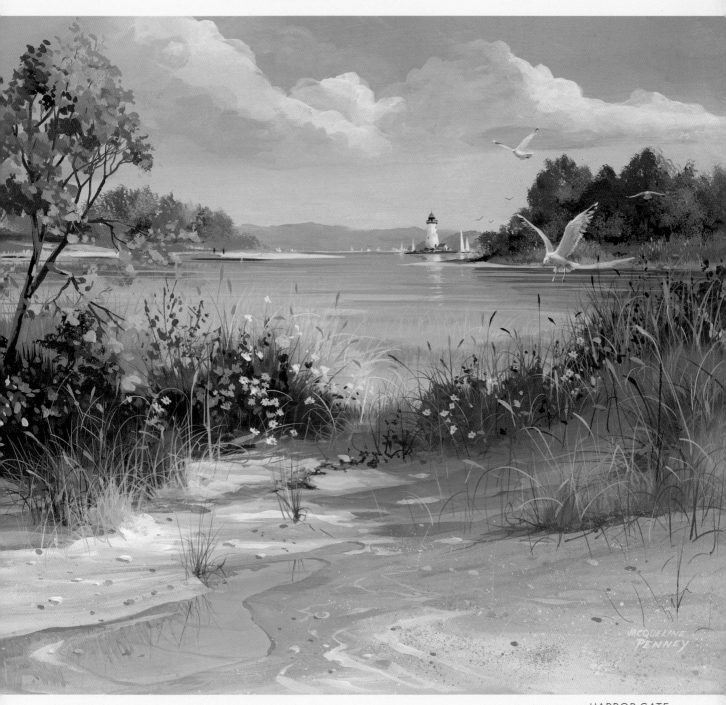

HARBOR GATE
22" × 28" (56cm × 71cm)
Acrylic on canvas
Collection of Tom Doolin

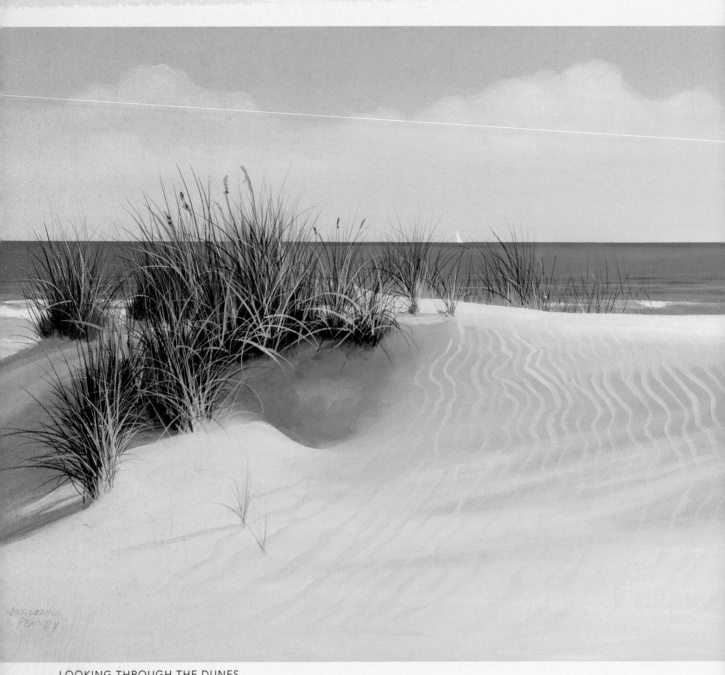

LOOKING THROUGH THE DUNES
22" × 28" (56cm × 71cm)
Acrylic on canvas
Collection of Deborah O'Connell
A demonstration of this painting begins on page 31.

INTRODUCTION

Technology offers the artist new ways to create. Computers and digital cameras make it easier and less expensive to take images and reproduce them. The computer has revolutionized our means of communication and offers the artist a vast area to explore and the opportunity to take advantage of the many programs that are available.

In the past I would use either slide or print film to photograph a subject, usually a landscape, seascape or still life. After developing the film I would then have to adjust the image to the size of the canvas I wanted to use or vice versa. For instance, I would make a small frame in proportion to the canvas and place it over the print to see the best composition for painting. For very intricate, detailed paintings I would use slides to project the image onto tracing paper that was attached and fixed to the picture frame. Then I would make a sketch on the paper. These techniques are thoroughly demonstrated in my book *Discover the Joy of Acrylic Painting* (North Light Books).

I have eliminated the film developing step and now use my digital camera with Adobe Photoshop on my computer to obtain the best composition. With this method I am able to quickly accomplish what used to take many days.

Before I used digital technology I kept all my slides in a box, with labels identifying each subject. I kept my prints in a file box organized by subject, such as water views, flowers, lighthouses, etc. Now I keep all my images on my computer under the major heading of *Photos*, with subheadings for each category. I also have a file system for all the paintings I have ever painted, listed by name, size, price, owner (if sold) and any other pertinent information. Early in my career I neglected to photograph some of my work, and now I wish I had. I encourage you to be diligent and keep accurate records of all your artwork.

I have been a teacher for many years and have learned that everyone can be taught to paint. It's just like learning your ABCs—once you know them you can be taught how to put them together and form words, sentences, paragraphs, stories and books. I have always claimed that if a person really has the interest and the time, I can teach that person how to paint, and I have proved it many, many times over the years. All it requires is commitment, time and the right tools.

The publisher of my fine art prints, Aaron Ashley of Bentley Publishing Group in California, takes almost everything I paint that has water in it. So this book is devoted to water scenes, and I am lucky enough to live in an area that is surrounded by water.

I live and maintain a studio/gallery in Cutchogue, New York, about one hundred miles east of New York City. There are two forks at the end of Long Island: the South Fork has the well-known Hamptons and the Atlantic Ocean, and the North Fork, where I live, is mostly farmland and vineyards. If I drive two or three miles south I encounter Peconic Bay, and if I head north about the same distance I see Long Island Sound and the distant coastline of Connecticut. So you see, I have a lot of subject matter close at hand to help me demonstrate how to *Paint Charming Seaside Scenes with Acrylics*.

I consider myself a realist, not a photorealist. A photorealist is an artist who depicts a scene or still life so accurately it resembles a photograph. I like to play with my paints and implements to create the illusion of realism. Most accomplished artists have a style or technique they've developed that gives their work a personality. I can teach a roomful of students every technique I know, but none of them will come up with the same style. I can even give them the same photograph from which to work, and there still won't be any duplicates.

My analogy to explain this phenomenon is that would-be artists need to learn many skills and techniques so they have a vast reservoir of knowledge from which to choose when trying to accomplish a work of art, just as an author has years' worth of knowledge about words and how to put them together. We are not born knowing how to read, write or paint; these are teachable skills. I will demonstrate and teach you every technique I know to help you develop a resource of painting skills. Then it will be up to you to use one or many of them to create a work of art—*your* work of art.

PAINTING GROUNDS AND SUPPORTS

There are many types of supports available to artists. Experiment with a variety until you find what works best for you. Here I discuss two of my favorites.

Canvas

The most commonly used support is canvas, which is made from cotton, linen, jute or synthetic fibers. It may be purchased by the yard, in large rolls or in various sizes that are ready to paint. I demonstrate on both prestretched primed cotton canvas and canvas that I have stretched and primed myself.

For Project 8, *Wednesday*, I stretched heavy-duty cotton duck over heavy-duty stretchers, wrapped it around the edges and primed it with two coats of gesso. Prestretched canvas is available with the canvas wrapped around the edges of the stretchers so it can be hung without a frame whether you paint the edges or leave them natural.

Luan Board

In Project 10, *Two for One*, I use luan board because it can be sawed in half. It is thin, fine-grained plywood and is very light. It may be purchased in 4' × 8' (122cm × 244cm) panels from a lumber supply company, but you can ask the lumber yard to cut pieces in smaller sizes.

Sand one side of the panel with medium/fine-grit sandpaper, by hand or with an electric sander. Apply one coat of water-based varnish (refer to sidebar on page 45) with a large bristle brush or sponge brush using smooth, even strokes.

When dry, sand the surface again with medium/fine-grit sandpaper, then turn the panel over to the other side and repeat the process. Be sure to cover the edges as well.

Once the entire board is dry, paint one side with gesso. You may need to use two coats, sanding between coats. The prepared luan board can also be used as a backing board for watercolor paper when you wish to use acrylics as you would watercolor.

BRUSHES AND OTHER SUPPLIES

Brushes used for the projects in this book include flats, rounds and liners (also called riggers).

The brush used most often is a 1" (25mm) flat, but you'll also need flats of these sizes: ¼" (6mm), ½" (13mm) and 1½" (38mm). You may want to purchase a 2" or 3" (5cm or 8cm) sponge brush as well.

The round brush sizes you'll need are numbers 0, 2, 4 and 6 (smallest to largest).

Liner or rigger brushes are used to make thin lines or to elongate tall grasses. The sizes you'll need are numbers 2, 4, 6 and 8.

When your brushes become worn and splayed, don't throw them out; they'll work great for stippling or for pulling up small areas of grass.

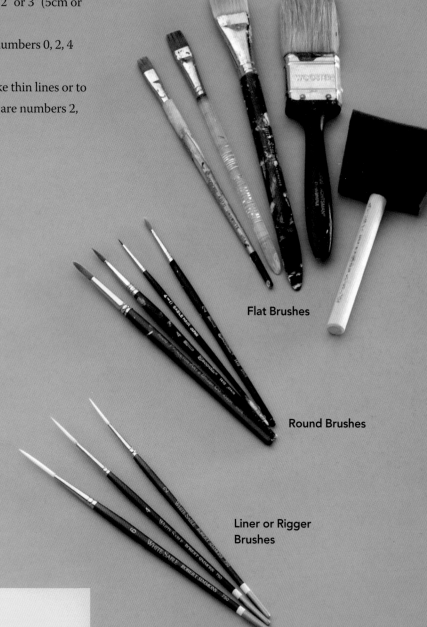

Flat Brushes

Round Brushes

Liner or Rigger Brushes

Caring for Your Brushes

Never let your brushes dry with paint in the bristles! Although acrylics are water-based, once they dry on a brush (or clothing) they never come out.

While working, always slosh your brushes in a water bucket to get most of the pigment out of the bristles before setting them down to do something else. (And be sure to clean out your bucket and replenish the water when it gets cloudy with paint.)

When you finish painting, take your brushes to the sink. Use warm water and liquid soap to work out the paint, and rinse the bristles thoroughly.

Other Materials

Additional items you'll need include acrylic glazing liquid, matte medium, molding paste, masking fluid, masking tape, charcoal, white chalk, palette knives (straight and angled), toothbrush, yardstick, pencil, eraser, magnifier, hair dryer, plastic wrap, sandpaper, transfer paper (white and black) and tracing paper. Check the materials list at the beginning of each project for items not mentioned here.

CHOOSING YOUR PALETTE

There is a wide range of beautiful paint colors from which to choose, and you do not have to use the exact colors that I have on my palette. However, I suggest you start with the following as a limited basic palette:

- a warm hue and a cool hue of each of the primary colors (red, yellow and blue)
- one of each of the secondary colors (orange, green and purple)
- Neutral Tint
- Mars Black or Payne's Gray
- a large container of Titanium White, which you will use often when mixing colors.

Earth tones are good to have as well, especially if you are painting a landscape. Make a wish list of other colors and give it to your friends and family for gift ideas.

Cadmium Yellow Primrose (cool yellow)

Hansa Yellow (warm yellow)

Pyrrole Orange

Cadmium Red (warm red)

Quinacridone Magenta (cool red)

Dioxazine Purple

Ultramarine Blue (warm blue)

Cobalt Blue (true blue)

Cerulean Blue

Phthalocyanine Blue (cool blue)

Prussian Blue

Phthalocyanine Green

Chromium Oxide Green

Hooker's Green

Jenkins Green

Yellow Ochre

Raw Sienna

Burnt Sienna

Burnt Umber

Raw Umber

Neutral Tint

Mars Black

Titanium White

Primary and Secondary Colors

The three primary colors are red, yellow and blue. Any two of these colors can be mixed together to create a secondary color: red mixed with yellow will make orange; red mixed with blue will make purple; and blue mixed with yellow will make green.

Colors that are directly across from each other on the color wheel are called complementary because they enhance each other when placed side by side. Mixing a primary color with its opposite, however, will create gray. Instead of adding gray pigment to a color, you can mix the color with its opposite to gray it down.

An easy way to remember complementary colors is to associate them with something else: red and green recall Christmas or the holidays; blue and orange might remind you of Halloween; and yellow and purple could make you think of spring or Easter.

SETTING UP YOUR PALETTE

The colors you will need for the projects in this book are listed at the beginning of each project. Prepare your palette in advance so you don't have to stop, open jars and put color on the palette when in the middle of a painting.

There are many manufacturers of fine acrylic paints and mediums. I have used most brands and have found them all to be acceptable with only minor differences, but my favorite is Golden Artist Colors.

My palette is a large white enamel butcher's tray that I found at a garage sale. Porcelain enamel trays can be ordered on the Internet or purchased at art stores. I recommend using a tray that is at least 13" × 17" (33cm × 43cm) so you'll have a large mixing area.

1 FOLD
Use a sturdy brand of paper towel and fold it three times into a long strip. Then fold it twice in the other direction so it becomes a small rectangle.

2 DUNK
Submerge the folded paper towel in water, then squeeze out the excess water so it is just damp, not wet.

3 COVER EDGES OF PALETTE
Open the last two folds you made in the paper towel and place the elongated strip along the inside edge of your tray. Repeat until you have at least three inside edges of your palette covered with damp paper towels.

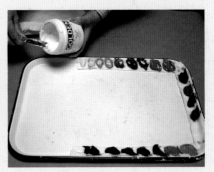

4 PLACE COLORS
Load a good amount of pigment onto the damp towel with a palette knife if using jar paints, or squeeze the paint out of tubes. Continue adding colors in a counterclockwise direction, starting with the lightest hue (Cadmium Yellow Primrose). I like to load my palette the same way each time so I always know where to find the colors I need.

Put 'em Away

One way to store your paints after cleaning up is to place two wet sponges, one on top of the other, in the middle of your tray, then cover the tray with plastic wrap, making sure to press down around the edges. If your palette is large, you might need two strips of plastic wrap to cover it entirely. The wet sponges will hold the plastic wrap in place above the paints.

You can also cover the tray with a piece of cardboard or plastic cut slightly larger than the tray, then place the tray in a plastic trash bag. This will keep the bag from coming in contact with the wet paint and making a mess.

Ocean Walk

MATERIALS

PIGMENTS

Burnt Sienna

Burnt Umber

Cobalt Blue

Hansa Yellow

Mars Black

Raw Sienna

Raw Umber

Titanium White

Ultramarine Blue

BRUSHES

1" (25mm) flat

1½" (38mm) flat

OTHER

Acrylic glazing liquid

Jones Beach in Long Island is a popular place year-round, but in the summer it's jam-packed with people looking for a place to cool off. I spent many sunny days there walking the beach. If you walked far enough, you left the crowds behind. One day in particular, a combination of sun and moisture created a beautiful glow, almost like a halo, way off in the distance, and as I walked toward the glow it felt like I was pulled into its center. Many years later I can still experience that feeling. The beauty of the artist's life is that we pull experiences and emotions from our very being and create with them.

For *Ocean Walk*, the composition is very simple: a horizon line, sand on the left and ocean on the right, and a couple walking hand in hand. The wave residue on the sand creates a lovely pattern and reflects the blue sky and distant glow. The figures are just silhouettes and too far away for any detail. But, as tiny as they are, they are the focal point in this painting—two people being drawn into the halo of light.

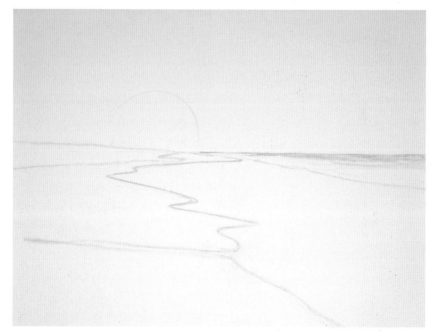

1 ESTABLISH THE MAIN ELEMENTS
Draw the horizon line and basic shapes with watery blue pigment.

"The beautiful is in nature, and it is encountered under the most diverse forms of reality. Once it is found it belongs to art, or rather to the artist who discovers it."

—Gustave Courbet

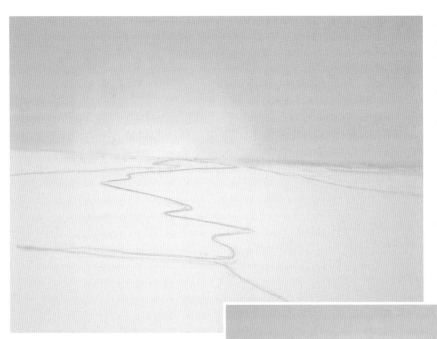

2 PAINT THE SKY

Using a 1½" (38mm) flat, paint the sky with a combination of Cobalt Blue, Ultramarine Blue and Titanium White. Add more Titanium White to the blue mixture as you go downward. To create the glow, add Titanium White near the base of the glow and brush it upward, making your brushstrokes sweep in an arc. Use acrylic glazing liquid or the drybrush technique to soften the edges of the glow. This may take several tries. There are very subtle changes in the values, and you need to see how it looks when dry before you adjust.

3 PAINT THE OCEAN AND SAND DUNES

Using the 1" (25mm) flat, paint the ocean with a combination of Ultramarine Blue and Cobalt Blue and gray it down slightly with a touch of Mars Black. Use Titanium White to create the bright sand dunes. It may take two coats to cover the sketch lines. Block in some of the wet sand.

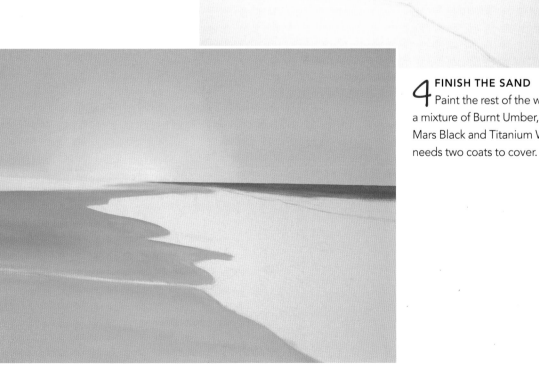

4 FINISH THE SAND

Paint the rest of the wet sand with a mixture of Burnt Umber, Raw Sienna, Mars Black and Titanium White. This needs two coats to cover.

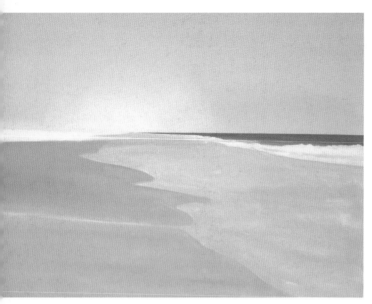

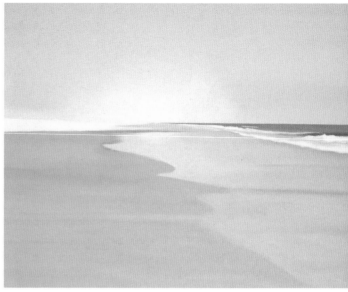

5 BEGIN THE WAVES

Paint the backwash of the waves a light blue for the first coat. Now you can see if the values and hues need to be corrected between the wet sand and the watery backwash. The distant area is diffused because of the haze. Begin to paint the waves using pure Titanium White and a little light blue-green.

6 REPAINT THE BACKWASH

Repaint the blue backwash on the beach that is slightly darker near the water and becoming lighter as it approaches the sand. Some sand will show through in the foreground and can be drybrushed with the sand color in a horizontal streak when the area is dry. Adjust the wet sand color with another coat of tan. Use Titanium White to drybrush the white reflection of the halo on the backwash. Develop the wave action with subtle color variations using a pale blue mixture and aqua tints, made with Cobalt Blue and Hansa Yellow, so the white waves will be contrasted. With a very light green, put in tiny shapes on the dunes to indicate grasses that are barely visible.

7 ADD THE FIGURES

The figures have very little detail. Start with a tiny circle for each head, using Raw Umber and a little Titanium White. For the bodies, use Burnt Sienna mixed with Titanium White to give them warmth; bring the paint down to the feet so that there is a head, an elongated *V* shape for the body and the legs that almost come to a point at the feet. There is a touch of red on the bathing suits, and the heads are a little darker than the bodies. The reflections in the water are two elongated shapes in the skin tones. With a light blue, put a couple of ripples over the reflections. Spatter the foreground beach area with a paler sand color and a watery Raw Sienna. Wipe any spatters away from other areas before they dry.

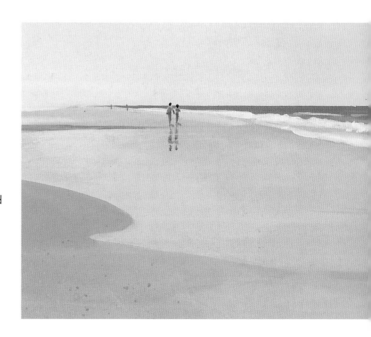

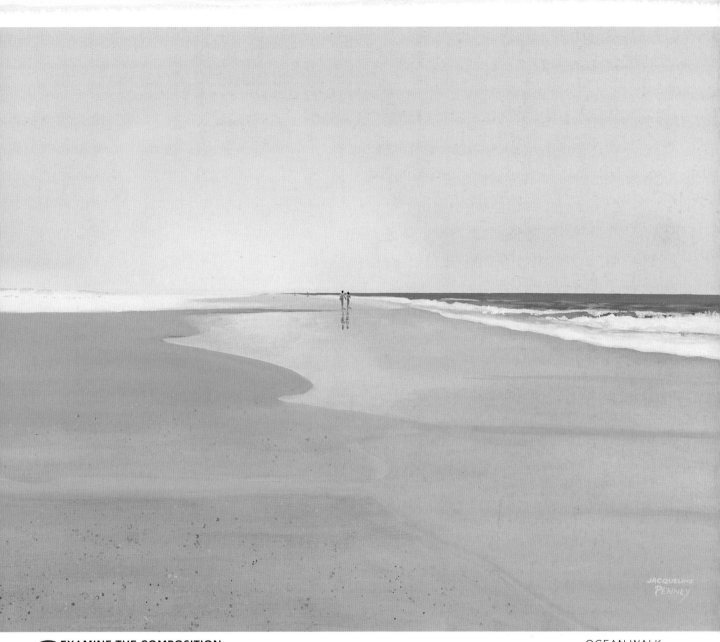

8 EXAMINE THE COMPOSITION
The figures are right in the middle—usually a no-no when planning a painting, but what saves the composition is the fact that the figures and the halo of light are combined into one. The halo is to the left of the figures, and that's where the eye is led. There are two horizontal stripes in the foreground, one in blue on the sand and one in tan on the backwash. These stripes accentuate the horizontal theme and add interest.

OCEAN WALK
18" × 24" (46cm × 61cm)
Acrylic on canvas

Sunrise Squared

MATERIALS

PIGMENTS

Cadmium Red

Cobalt Blue

Dioxazine Purple

Hansa Yellow

Mars Black

Phthalocyanine Blue

Phthalocyanine Green

Pyrrole Orange

Quinacridone Magenta

Titanium White

Ultramarine Blue

BRUSHES

½" (13mm) flat

1" (25mm) flat

OTHER

Acrylic glazing liquid

Yardstick

Using a square rather than an elongated rectangular canvas can motivate you to paint a scene with a different or unusual composition. Seascapes naturally lend themselves to long rectangles, but for the following demonstration, I used a square canvas. The 12" × 12" (30cm × 30cm) canvas is an unusual ground for an expansive sunrise, and that's why I chose it. A square shape almost gives the image a feeling of being contained. Challenge yourself to create unusual paintings using different shapes, and enjoy condensing an expansive topic into a small frame. Canvas can be purchased in so many different shapes that it's fun to try them all. The possibilities are endless.

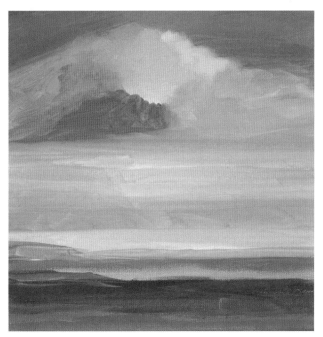

1 PAINT THE FIRST COAT

Instead of drawing with a pencil, I used a 1" (25mm) flat brush to create the inital shapes and colors. Begin at the top and use Cobalt Blue and Ultramarine Blue with Titanium White. Add the white cloud and tints of orange made with Pyrrole Orange and Hansa Yellow, and to that, mix in Quinacridone Magenta, which is a cool red. This first coat is just to show loosely where you want the different colors to go; remember, this process will take two or three coats of paint.

2 ADD A SECOND COAT

Use a ½" (13mm) flat and work your way down. Now that you have the painting blocked in, paint it again to make the lights lighter and the darks darker. Blend the delicate colors with your finger. To keep the horizontal bands level, use a tilted yardstick to steady your brush (see page 39). If you need to keep the pigment moist, mix acrylic glazing liquid into the paint. It may be necessary to paint three coats to blend in the subtle colors.

"Art is just a pigment of your imagination."

—*Tony Follari*

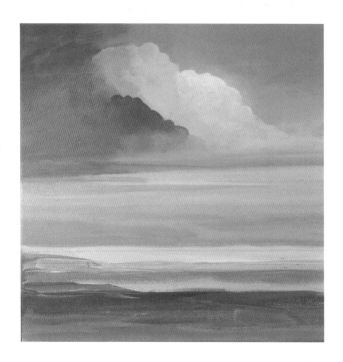

3 ADD THE COLOR LAYERS

Continue to add layers of color with fairly thick paint. The more paint you apply, the easier it will be to blend the colors. The abundant cloud area is balanced by the multiple stripes of color below. The horizontal strokes themselves suggest a peaceful mood, and the varied colors make it more interesting. The rich, dark colors can be made with Phthalocyanine Blue and/or Green mixed with a little dark red made from Cadmium Red and Mars Black. A full palette will give you many choices; for instance, three different blues were used. The rich purple and deep blues are pure and not mixed with anything.

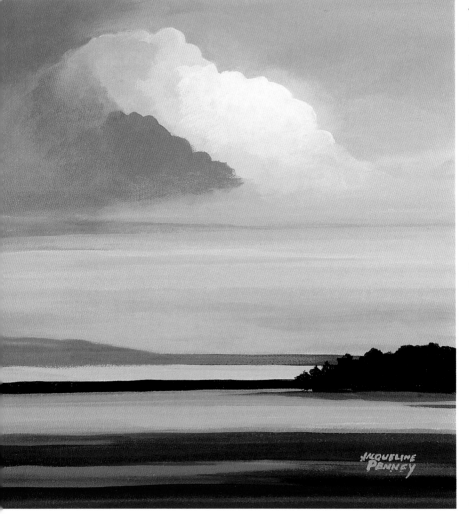

SUNRISE
12" × 12" (30cm × 30cm)
Acrylic on canvas

Driftwood in the Dunes

MATERIALS

PIGMENTS

Burnt Sienna

Burnt Umber

Cerulean Blue

Chromium Oxide Green

Cobalt Blue

Dioxazine Purple

Hansa Yellow

Mars Black

Neutral Tint

Phthalocyanine Green

Pyrrole Orange

Raw Sienna

Titanium White

Yellow Ochre

BRUSHES

½" (13mm) flat

1" (25mm) flat

1½" (38mm) flat

Nos. 2, 4 and 6 riggers

No. 4 round

OTHER

Acrylic glazing liquid

Masking tape

Matte medium

Pencil

Toothbrush

Yardstick

There are different dunes and grasses throughout our seacoasts, and they vary with the climate. In the tropical zones I have visited, the dunes seem to be flatter and the water a beautiful aqua color (probably due to the Gulf Stream), versus the dunes in Oregon, which are huge and surrounded by water that is a dark blue. The painting in this demonstration was inspired by a piece of driftwood my son-in-law picked up on the beach during a trip to Sarasota, Florida, where the dunes are flat.

The painting was done on a 15" × 30" (38cm × 76cm) canvas, which is a ratio of 2 to 1, so any small thumbnail frame such as 5" × 10" (13cm × 25cm) will work in proportion to the canvas if you wish to sketch the scene. If you're a computer-savvy artist, the composition and sketch can be done using Photoshop, which is what I did. The sketch gave me inspiration, but I made decisions as I went along to alter the painting and balance the shape, value and composition. There is no wrong or right way to come to the same conclusion, so do what is comfortable for you.

1 START WITH THE BASIC SHAPES
Use a pencil and measure down 4½" (11cm) from the top to establish the horizon line. Sketch the main elements of the scene such as the wave area, dune shapes, driftwood and grasses. Paint the sky a light Cerulean Blue, adding a touch of Mars Black or Neutral Tint to gray it down. As you approach the horizon, add a little Titanium White and a small amount of Pyrrole Orange to warm it up.

2 PAINT THE WATER

When the sky is dry, mark the horizon line evenly on both sides and draw a line across. Place masking tape on the horizon and use matte medium to seal the edges. Make sure it is dry before you begin the next step. The first ½" (13mm) stripe of paint is a darker blue than the rest of the water, signifying the deep ocean in the distance, made with Cobalt Blue mixed with a little Titanium White and Mars Black to gray it down. As you brush across and downward, add a small amount of Phthalocyanine Green and Titanium White and blend it in. Lighten the water as you come downward toward the shore and add a little Yellow Ochre to the mixture to suggest sand under the shallow water. The wet sand color next to the water is kind of pink made with a combination of Burnt Sienna, Burnt Umber, Yellow Ochre and Titanium White. The dry beach sand is very light and made with Yellow Ochre and Titanium White.

3 MAKE THE WAVES

Mix Titanium White with a little Phthalocyanine Green and Cobalt Blue and create the almost white waves using a no. 4 round and resting it on a tilted yardstick (see page 39), adding pressure then releasing it as you come across to create the breakers. Use the same mixture to make the foamy action near the shore with the tip of a no. 4 round. Mix Cobalt Blue and a little Mars Black to make darker wave action. With Titanium White, go over the crest of the waves and also make a continuous thin line where the water ends. Once the grass is painted it will be hard to go back and correct the water, so make sure you are happy with it. However, even if you start the grasses and don't like the water, you can paint over all of it and start again. That's the joy of acrylic painting!

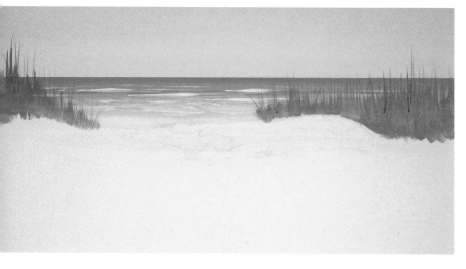

4 MAKE ANY CHANGES AND ADD THE BEACH GRASS

I was not pleased with the brown color for the wet sand and decided to soften the edges and add a couple more little swells in the water. This is the time to make changes to that area, before beginning the grasses. Some of the grass is behind the dunes and driftwood. Use a mixture of Chromium Oxide Green, Burnt Sienna, Hansa Yellow and Titanium White for the first application of grass. Use a 1" (25mm) flat, flipping it upward to simulate the small grasses, then twist the brush so that only the sharp edge of the brush is used to sweep the longer grasses upward in a thin line. Then use a no. 2 or 4 rigger to sweep more grasses up over the horizon and into the sky area with the same mixture, but make it more fluid by adding a little more water.

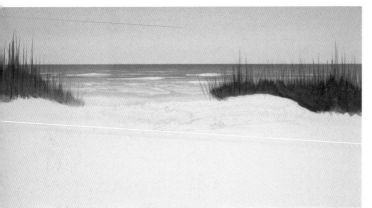

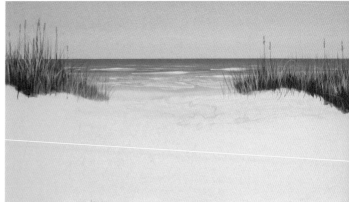

5 CONTINUE ADDING THE GRASS

Use Phthalocyanine Green and Burnt Sienna to make a darker value for the next application of grasses, and lay them in as you did in step 4. The grass on the right extends farther toward the center than the grass on the left, so it doesn't look even on both sides.

6 CREATE CONTRAST IN THE GRASS

Using a no. 4 or 6 rigger, paint lighter grasses over the dark to create contrast. Make some yellow-green and some mixtures of Yellow Ochre to suggest old grass that is no longer green. Continue this process until you are satisfied with several layers of grass.

Add heads to some of the straight grasses. Using a ½" (13mm) flat, tip upward at the base of the grasses with a dark mixture of Phthalocyanine Green and Burnt Sienna. At this point there are approximately seven layers of grass using a variety of values and colors. The almost white strokes of grass will pick up the glazing in the next step.

7 GLAZE

Go over the grasses with a mixture of acrylic glazing liquid and Yellow Ochre. The light grasses will pick up the tint of yellow. Use a no. 4 rigger to add more light and white grasses in preparation for more glazing.

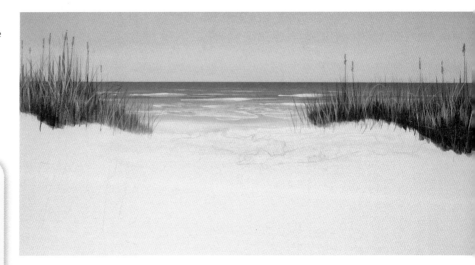

Glazing

A wonderful way to bring a glow, especially to light grasses, is to use acrylic glazing liquid or matte medium mixed with yellows and other colors and lightly brush over the area. Experiment with glazing on areas of your painting that you want to liven up, and if you don't like the results or the color is too dark, just wipe it off with a damp paper towel. That's the joy of acrylic paint!

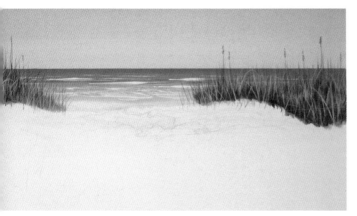 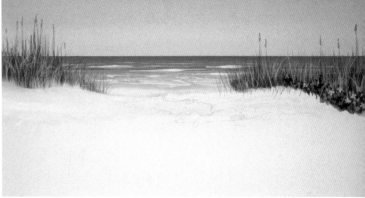

8 GLAZE AGAIN

This time, glaze over the grass on the right with Burnt Sienna to give it a warm glow. Compare the left and right grasses to see the difference between glazed and unglazed areas.

9 GLAZE AND ADD THE FLOWERS

Repeat step 8 on the left side of the painting. Cover the bottom of the grass area with a very light color made from Yellow Ochre and Titanium White, then flip the brushstrokes up over the base of the grasses with a ½" (13mm) flat and pull that color a little higher with a no. 4 rigger. This becomes a transition between the sand and the grass and will be glazed with color in the next step. Paint a few yellow flowers with four petals (these may need two coats to cover over the dark area). Mix two shades of green: a light green made from Phthalocyanine Green, Hansa Yellow and Titanium White, and a dark green made from Burnt Sienna and Phthalocyanine Green. Dot these colors over the grass area with the tip of a no. 4 round.

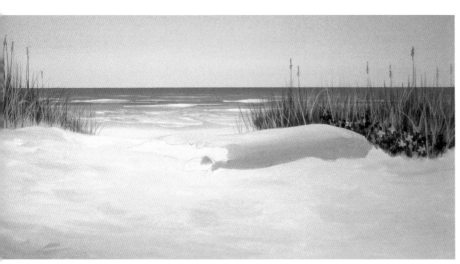

10 RE-ESTABLISH THE DRIFTWOOD AND PAINT THE SAND

Re-establish the shape of the driftwood with a pale, light gray-blue. The driftwood is basically a cylinder on its side, with the lightest area on the top. The true color of the driftwood in the middle is a medium value made by adding a little more blue, Mars Black and a touch of Burnt Umber to the light gray-blue mixture. Underneath is a warm medium-dark value made from Burnt Sienna, Raw Sienna and Mars Black added to the mixture. It is a warm color because it picks up the reflected temperature of the sand. The hollowed-out interior area will be the darkest. Paint the sand with a 1" (25mm) flat and use combinations of Titanium White with the following colors: Pyrrole Orange, Yellow Ochre, Raw Sienna, Burnt Sienna, Cobalt Blue and Dioxazine Purple (all in very light tints). Paint quickly and blend slightly with the wet paint, but allow the colors to remain recognizable. This gives the illusion of footprints in the sand, and the color adds interest.

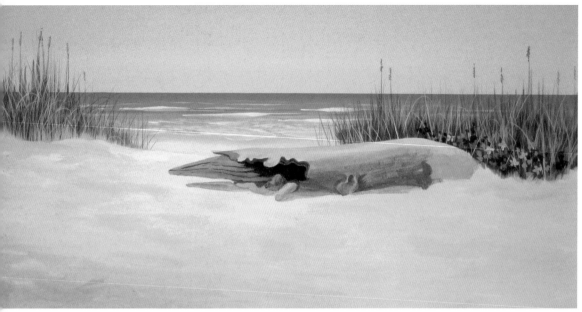

11 BEGIN THE DRIFTWOOD

The driftwood is simply shaped with hard and soft edges, knots and grain texture. Establish the lightest and darkest areas so you can balance the medium values and colors. There is an interior shape that will be a warm, dark color. Within each value (light, medium and dark) there are variations of colors. In other words, you can add interesting colors to a value and it will remain the same value, only more interesting. This was done in the sand area (all a light value, but with colors added).

Use drybrush and glazing techniques to model the driftwood, and place shadows on the sand and underneath the driftwood. The basic colors are Burnt Sienna, Raw Sienna, Yellow Ochre, Titanium White and Mars Black.

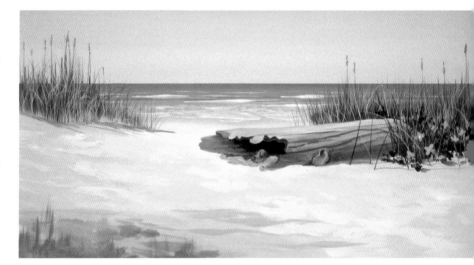

12 GO WITH THE GRAIN

To elongate and simplify the driftwood, make the right end curved. Round out the jagged left side slightly by bringing the beach color over it. The beauty of acrylic paint is that you can make major changes with little effort. The driftwood has crisp edges and stands out a little too much in this softly rendered area. To subdue it slightly, bring some of the grass and yellow flowers in front of the driftwood so they overlap it. This camouflages and softens the hard edges, pushing them away from the viewer.

Add blue-gray shadows where the foreground grasses will stand before you add the grasses. Go over the sand area with Titanium White tinted with Yellow Ochre and Pyrrole Orange, then add a light blue-gray near it to create shadow-like depressions in the sand. In preparation for the foreground, create shadows to the right and then darken the area where the grass will be with Burnt Umber mixed with the shadow color to make a light, medium value.

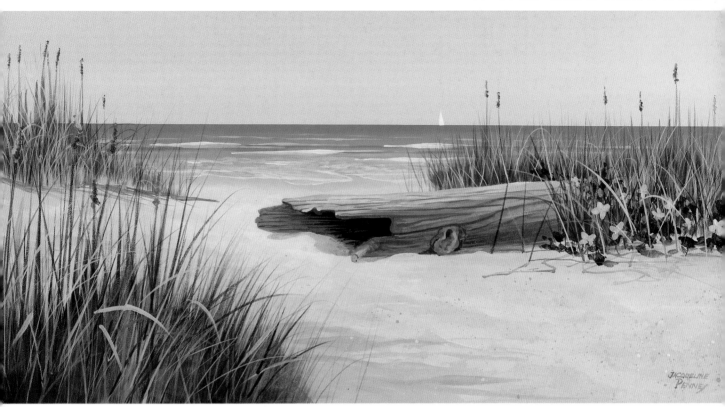

13 ADD THE FINISHING TOUCHES

Simplify the driftwood shape by adding more grain and putting more sand and shadows inside the opening. Glaze with Raw Sienna near the top and Burnt Sienna near the bottom. Place a tiny sailboat in the distance (see page 58, step 12). Sharpen the intensity of the yellow flowers. Use calligraphic brushstrokes (see sidebar on page 44) to simulate grass debris in the sand area, and glaze with Raw Sienna near the base of the driftwood and onto the sand in front of the grass.

Spatter several bland colors in the foreground using a toothbrush (see page 40, step 5). The larger foreground grasses are made with several values and shades of green. Use a 1½" (38mm) flat and a no. 6 rigger to extend the grass upward. Darken all the seed tops with a warm, dark color made from Burnt Sienna, Raw Sienna and a little Mars Black.

There is a light pathway that curves to the right, leading to the water and the sailboat in the distance. The driftwood is the main focal point and has developed into something quite different from the 24" (61cm) piece of driftwood that inspired the painting. It now has the illusion of being much larger because of its relationship to the beach grass. The choice of an elongated canvas supports the expansive, restful scene.

"Change and risk-taking are normal aspects of the creative process. They are the lubricants that keep the wheels in motion. A creative act is not necessarily something that has never been done; it is something you haven't done before."

—*Margaret Mead*

Misty Days

MATERIALS

PIGMENTS

Burnt Sienna

Burnt Umber

Chromium Oxide Green

Hansa Yellow

Mars Black

Neutral Tint

Payne's Gray

Phthalocyanine Blue

Raw Sienna

Titanium White

Yellow Ochre

BRUSHES

1½"(38mm) flat

No. 2 rigger

No. 2 round

1" (25mm) splayed flat

OTHER

Acrylic glazing liquid

Chalk or charcoal

Hair dryer

Masking tape

Matte medium

Palette knife for mixing

Pencil

Toothbrush

Yardstick

This sheltered inlet has a mirror-like surface that reflects marsh grasses, and this is one of the subjects I like to paint. It looks difficult, but it isn't. The best way to think about reflections of grasses is to realize that what goes up must also come down. In other words, each brushstroke of the grass that you paint in an upward motion is repeated in a downward motion below.

At medium or low tide there is a dark, muddy area around the base of the grass that gives it a richness of values and colors. Almost everything is subdued in this painting, especially the background, sky and water, because they are almost all the same color and value. The distant land is not defined—it's just a light to medium value of gray. To make the painting more attractive, a path is added and the grasses are undulating instead of straight up and straight across the midground, and some low bushes are added for interest. The focal point of this painting is the brighter foreground grass and reflection. The seagulls are secondary as they gently stir the air with their outspread wings. This type of painting conveys a feeling of peace because of the glass-like surface of the water and mist with close relationships of values.

Altered Reference Photo

I retouched the photo in Adobe Photoshop: added a pathway, higher grasses and seagulls; and eliminated boats, houses and bushes. The focal point is the reflection; the seagulls are secondary and add a gentle agitation to this otherwise tranquil scene.

Make Plenty of Your Mixure

When you know you will be using a lot of one mixture, use a palette knife and make more than you think you will need. Paint a dab of the color on a piece of paper, let it dry and then decide if it is the right color and value. Acrylic paint dries about one shade darker than when wet.

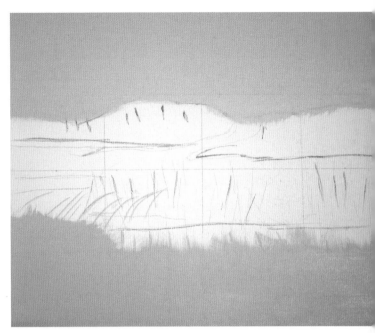

1 SKETCH THE COMPOSITION
This painting is basically divided into thirds. Make a grid and lightly draw the basic shapes onto the canvas with a pencil and/or a watery mixture of pigment using a no. 2 round. Use a palette knife to mix a large quantity of the sky color from Phthalocyanine Blue, Titanium White and Neutral Tint or Mars Black to gray it down. You will use this mixture again as a base to make several different values. Place the mixture near the edge of the palette, away from the mixing area.

2 PAINT THE SKY AND WATER
Paint the sky and water at the same time with a 1½" (38mm) flat. The distant land will be painted on top of this color when it is dry.

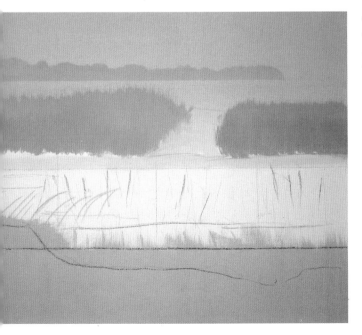

3 PAINT THE DISTANT LAND
Re-establish the grid line with chalk or charcoal and show the shape of the distant land and where the grass area will be. Use the same color you mixed for the sky and water, but make it just a little darker blue-gray for the distant land by adding very small amounts of Burnt Umber and Payne's Gray. The close value change makes the distant land seem misty. Test the color to make sure it is the right value (it will dry darker). Mark the line of the distant land and use a yard-stick to steady your hand (see page 39), or use masking tape and paint the distant land so it is level on both sides. Paint the tree area, giving it interest by making it undulate and not go in a straight line. The grass is quite pastel and subdued and will be a light-to-medium value made with combinations of Chromium Oxide Green, Yellow Ochre, Raw Sienna, Burnt Sienna, Hansa Yellow, Mars Black and Titanium White. If there is leftover paint from the sky and water mixture, add some of that to the grass mixture as well. Reserve dark values for the foreground grasses and reflections.

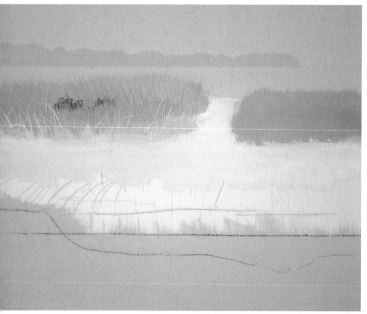

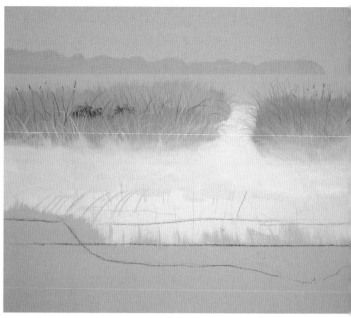

4 REPAINT THE PATHWAY AND GRASSES
Use either a 1½" (38mm) or 1" (25mm) flat and repaint the pathway. Mix several pastel greens and tans for the grasses using Chromium Oxide Green mixed with different pigments such as Yellow Ochre, Raw Sienna, Burnt Umber and Titanium White. Pull the strokes upward with a no. 2 rigger. (For this area I used at least eight different combinations of light colors, and I held a hair dryer in my hand to immediately dry the area before I added more grass so I could see the final color.) The clumps of weeds and small shrubs are a little darker in value can be stippled in.

5 PAINT THE OTHER SIDE
Repeat the same process on the right side and add darker grass with little heads for interest.

6 ADD THE MARSH GRASS AND REFLECTIONS
Go over the sandy area above the marsh grass and create interest with calligraphic brushstrokes and by spritzing some areas with colors using a toothbrush. Dry that area and start with the top of the grasses, which are a combination of Chromium Oxide Green and Raw Sienna applied with a splayed brush. Flip the brush upward to create the shape of the grasses, then use a no. 2 rigger with the same pigment to elongate the grasses up into the beach. This process must now be repeated in the other direction for the reflection in the water. If it's helpful, mark the center of the grass to judge the distance between real and reflected areas. Use acrylic glazing liquid or matte medium and glaze Yellow Ochre and greens over some of the grasses to add a little more color.

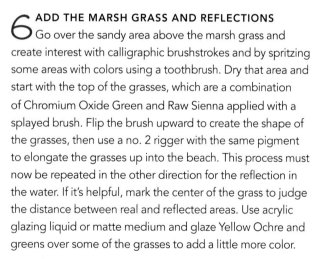

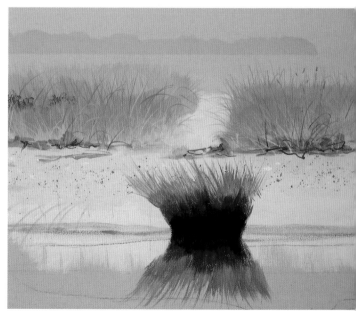

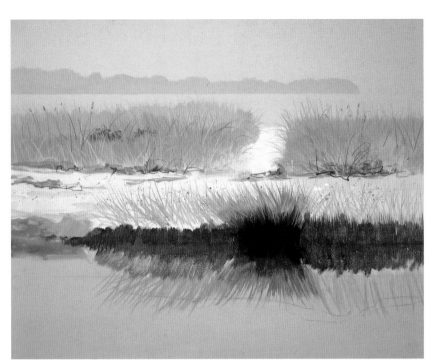

7 ESTABLISH MORE GRASS AND REFLECTIONS

With each layer of grass the color will change slightly and become more intense and darker as you near the mud flat. You will have to give the dark areas at least two coats to cover the white canvas. Each change you make to the grass in an upward motion must be repeated in a downward motion.

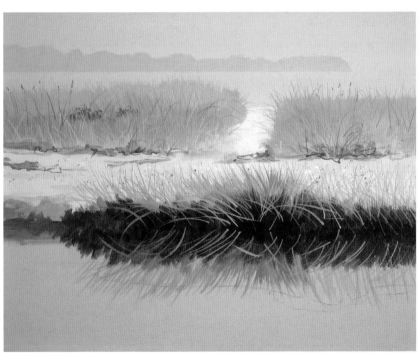

8 FINISH THE FOREGROUND GRASSES

Continue with the grasses, sweeping strokes upward and downward.

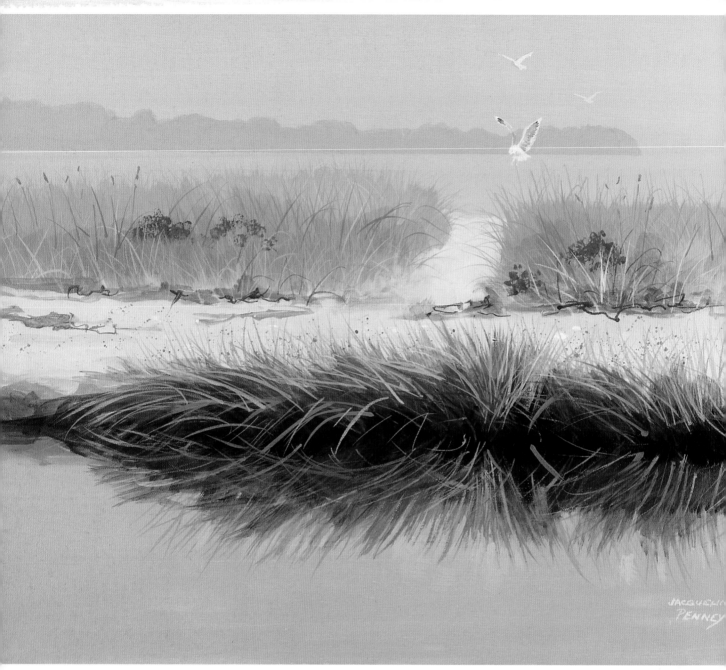

9 **ADD THE SEAGULLS AND COMPLETE THE GRASS**
The landing gull is a V shape. Think of the head as an oval on top of another oval that is the body, and the tail is a fan shape. The tips of the wings are a dark color that is in contrast to the white of the feathers. The other gulls are placed above the landing gull and do not have as much detail. Glaze the grass area again with Burnt Umber and add more light greens.

MISTY DAYS
18" × 24" (46cm × 61cm)
Acrylic on canvas

"Art is not what you see, but what you make others see."

—*Edgar Degas*

Looking Through the Dunes

MATERIALS

PIGMENTS

Burnt Sienna

Burnt Umber

Cadmium Red

Cerulean Blue

Chromium Oxide Green

Cobalt Blue

Dioxazine Purple

Hansa Yellow

Mars Black

Neutral Tint

Phthalocyanine Blue

Phthalocyanine Green

Prussian Blue

Pyrrole Orange

Raw Sienna

Titanium White

Ultramarine Blue

Yellow Ochre

BRUSHES

½" (13mm) flat

1" (25mm) flat

No. 4 rigger

Nos. 4 and 6 rounds

OTHER

Acrylic glazing liquid

Masking tape

Matte medium

Pencil

Yardstick

Over the years I have diligently looked at sand dunes, grasses and water to understand their construction and how I would go about painting them. Some dunes are kind of flat and some are huge with their soft, windblown, undulating shapes made distinct in bright daylight or by the shadows created by the angle of the sun. Some grasses are clumped together or loosely strewn over the dunes. I have a folder on my computer under *Water Scenes* with several photographs of dunes, and there is one I remember taking in the winter months. The grasses are drab and dull, but I can change that.

In Adobe Photoshop I removed the very top of the dune and added water instead. For this demonstration I changed the scene from winter to summer. One of my passions is painting beach grass, so I included some that are in the sun and some that are in the shade; the interiors are warm and dark, and there are many layers, each different in color and value. Instead of drawing the linear outline of the shapes with paint, I lightly drew the shapes with pencil, and with a very watery mixture of the local colors I painted the basic structure to block in the composition.

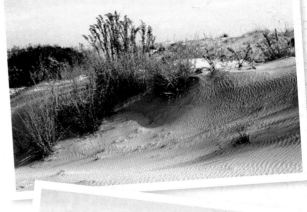

Reference Photo

I photographed this dune about a mile inland from the ocean in a place called "The Walking Dunes" on the south shore of Long Island. It's called that because the heavy winds shift the sands with such force that the sand even covers over some of the pine trees that ring the area. The dunes are never the same from day to day.

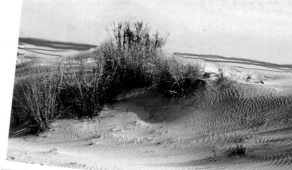

It's Like Magic

Adobe Photoshop was used to take off some of the top of the dune and to add water with some wave action in the distance.

1 ESTABLISH THE SHAPES

Use a pencil to lightly draw the horizon and shadow shapes, indicating where the clumps of grasses will be. Block in the areas using local colors of very watered-down pigment. For the sky, use a very watery combination of Cerulean Blue and Titanium White; Prussian Blue, Cobalt Blue and Titanium White for the ocean; then add a little Burnt Sienna to that mixture to make a warm gray and paint the shadow areas.

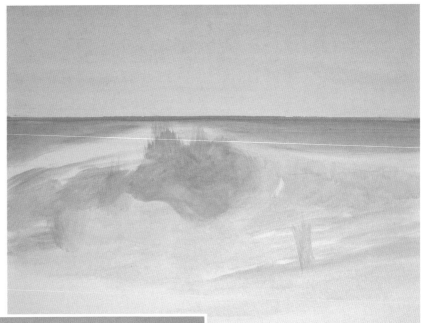

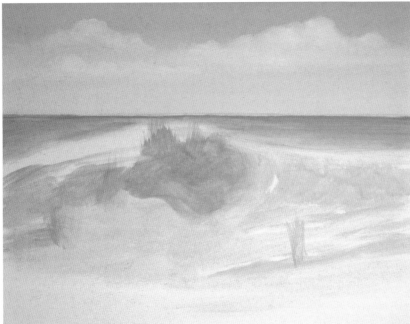

2 PAINT THE SKY

Starting at the top of your canvas with a 1" (25mm) flat, repeat the sky using Cerulean Blue mixed with a little Cobalt Blue and Titanium White; then add Pyrrole Orange as you approach the horizon to give it warmth. Place a few soft clouds in the sky while it is still wet, or wait for it to dry and use the dry-brush technique with Titanium White on the flat of the brush (not the tip). Acrylic glazing liquid can also be used to blend the clouds with the sky color.

Graying the Sky

Several pigments can be used to gray a sky color, including orange (the opposite of blue), Neutral Tint, Payne's Gray or Mars Black. If you want the sky near the horizon to be less intense and warmer, use orange; that will not only gray it down but also add warmth. Experiment with colors such as Burnt Sienna and blue to make a warm gray, possibly for a stormy sky. Neutral Tint is just that—a neutral gray (not warm or cool) that can be purchased in several values. Acrylic glazing liquid helps the blending process and keeps the paint moist and pliable.

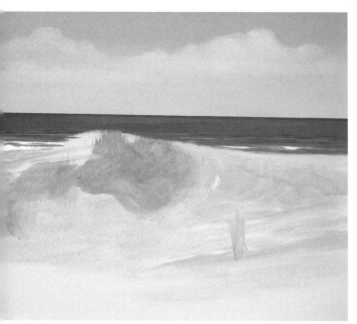

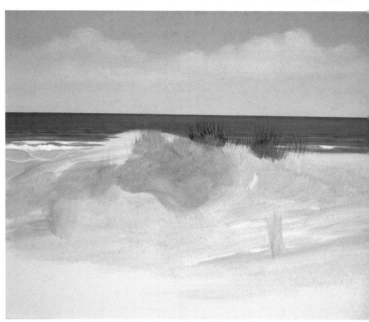

3 PAINT THE WATER AND WAVES

Measure and tape the horizon line and use matte medium to seal the edge. Mix Ultramarine Blue with a little Cobalt Blue, Mars Black and Titanium White to make a medium value. As you go down, every inch or so add a little more Titanium White, and near the bottom add a tiny bit of Phthalocyanine Blue, making the tint slightly turquoise blue. Create the wave action by mixing Cobalt Blue with a little Chromium Oxide Green and Titanium White to make a light value. Rest the ferrule of a no. 4 round on the edge of a tilted yardstick (see page 39) to keep it steady, and as you slide the brush across the canvas, press down and then release the pressure to create thick and thin waves. Near the area where the water meets the beach on the left, paint a light blue for the backwash and a sandy color for the beach with Titanium White and Yellow Ochre. Use Titanium White to go back over the waves and create crests; make the closest wave splashes larger. Mix a slightly darker value of the colors you used for the water and use the tip of a no. 4 round to lightly brush in elongated dashes behind the waves.

4 PAINT THE GRASS

Before you paint the dunes, there are grasses on the other side that need to be painted so the dunes can be painted over the base of the grasses, allowing just the tops to be seen. You are overlapping one object with another to give the feeling of depth. Mix Phthalocyanine Green with a little Mars Black to darken it, then take a ½" (13mm) flat that is splayed open and flip it upward to paint the grasses. With a no. 4 rigger, add a little water to that mixture and pull the color up higher over the water area. Mix a little lighter green by adding Titanium White and Yellow Ochre to the mixture and repeat the process. Make sure the underpainting is dry so you will get crisp lines.

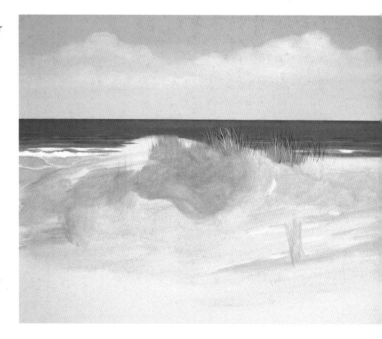

5 LAYER THE GRASS

The grasses are not just one or two colors. Repeat the last step by adding Yellow Ochre and Titanium White and going over the grasses. Then add a little Pyrrole Orange to that mixture and repeat the strokes. Finally, use just Titanium White and a no. 4 rigger to paint the blades of grass, some straight up and some bent over from the wind.

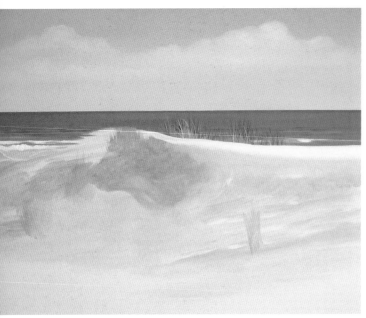

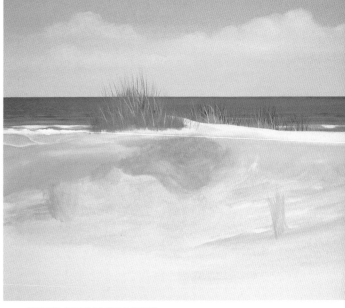

6 PAINT THE TOP OF THE DUNE
There is a flat area on the top of the dune in front of the grasses. Use a mixture of Yellow Ochre and Titanium White with a 1" (25mm) flat to paint the top of the dune over the bottoms of the grasses, pushing the grasses behind the dune. You may need to use a second coat. To that light mixture add a little dark red and a tiny bit of green (red's opposite) to gray it down and make a very light mauve color; blend it with the light mixture coming downward. Then to that mixture, add Cobalt Blue and blend as you stroke downward to make a smooth transition from a very light to a light-medium value with slight changes from warm to cool colors.

7 OVERLAP THE GRASSES
Use colors similar to those used in the grasses behind the dune and repeat the process of overlapping. The grass will now overlap the dune painted in step 6 and be slightly larger. The very light top of the dune goes across the canvas and separates the grasses, creating a path near the top of the dune. Phthalocyanine Green is mixed with Yellow Ochre and Raw Sienna to make it a warmer, less intense green.

8 PAINT THE INTERIOR GRASSES AND ADD SHADOWS
Use a 1" (25mm) flat and mix Cobalt Blue, Cadmium Red, Burnt Umber, Burnt Sienna, Dioxazine Purple, Pyrrole Orange and Titanium White to create the left side of the dune and the hollowed-out bowl. Start with the darkest mixture of Burnt Umber, Burnt Sienna and a little Titanium White and blue. Using the edge of the brush, stroke upward to create a jagged edge for the beginning of the interior of the grasses. To that mixture add a little Dioxazine Purple to change it slightly and blend it with the first color. With almost every brushstroke, create slightly different hues and values, and blend while wet to create a smooth transition from a dark to a light-medium value. The interior of the shadow is warm, and the form to the right side of the bowl is gradually blended with the dune color. The sun is to the right and slightly behind the dune, which creates a sharp cast shadow coming forward on the bottom of the bowl.

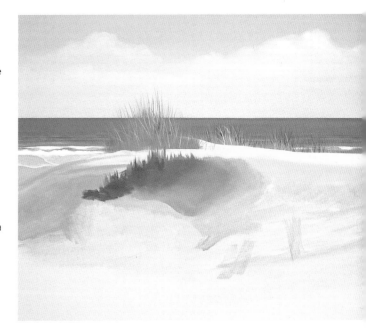

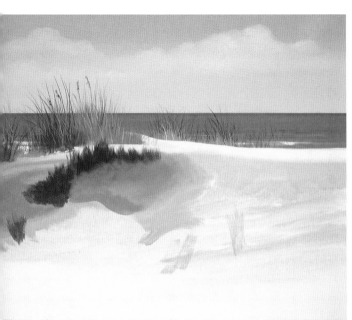

9 ELONGATE THE GRASSES

Elongate the grasses on top and give a few of them heads that are not all the same size or going in the same direction. Add more grasses to the left and elongate the grasses behind the dunes. Bring some of the beach color into the base of the new grasses so it is not a straight line going across the bottom. Adjust the shadow color on the left and within the bowl with a warm dark. The blue hue of the shadows is made from Cobalt Blue, Titanium White and a little Pyrrole Orange (blue and orange are complements).

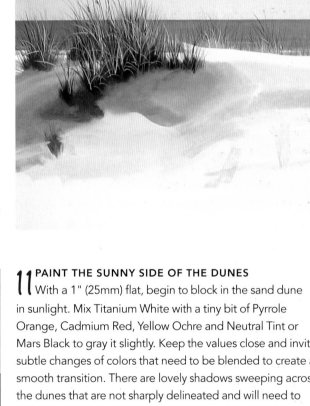

10 BALANCE THE COLORS AND VALUES

Continue to balance the colors and values between the grass and the shadow, using a finger to smudge the sharp edges of the brushstrokes at the base if necessary. Paint some of the grasses coming forward with a mixture of Pyrrole Orange, Burnt Sienna and a little Titanium White. Create them with circular movements using your whole arm to make the sweeping strokes. The contrast between the light warm grass and shadow background makes the grass pop out. Nothing will go in front of the grasses, so you can continue to work on them and add more. Use Titanium White to simulate grasses catching the sunlight.

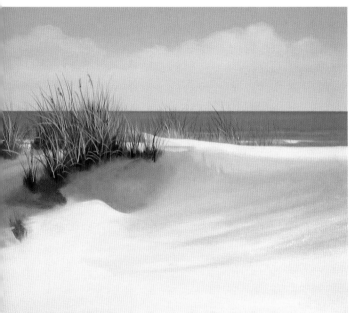

11 PAINT THE SUNNY SIDE OF THE DUNES

With a 1" (25mm) flat, begin to block in the sand dune in sunlight. Mix Titanium White with a tiny bit of Pyrrole Orange, Cadmium Red, Yellow Ochre and Neutral Tint or Mars Black to gray it slightly. Keep the values close and invite subtle changes of colors that need to be blended to create a smooth transition. There are lovely shadows sweeping across the dunes that are not sharply delineated and will need to be blended using acrylic glazing liquid or drybrushed to keep the edges soft. For the shadows, use a combination of Cobalt Blue, Pyyrole Orange, Cadmium Red and Titanium White. The brightest and lightest areas are on the top of the dune and near the cast shadow.

12 WARM IT UP

Warm the bottom and interior of the grasses with Burnt Sienna, and use a little bit of water or acrylic glazing liquid to wash away the bottom so there is no line. Add more grass in the foreground, overlapping light over dark and dark over light. The light grasses are almost pure Titanium White mixed with just a little Yellow Ochre or very pale yellow-green.

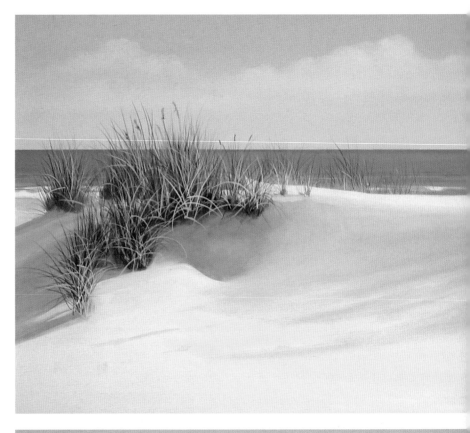

13 ADD A RIPPLE EFFECT

Mix a shade of blue-gray from Cobalt Blue, Titanium White and a very small amount of Neutral Tint to make it just a little lighter than the shadow areas. Begin at the top with a no. 6 round and zigzag downward and to the left. To soften the bottom of the lines, drybrush a little of the light color of the dunes over them. Add more very light grasses in preparation for glazing.

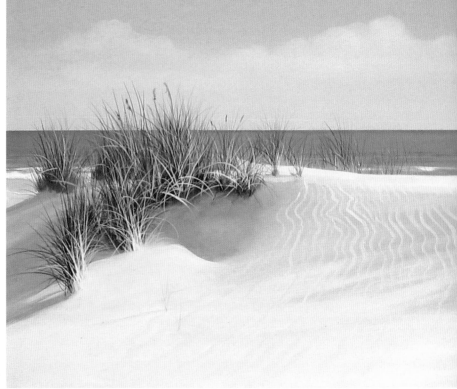

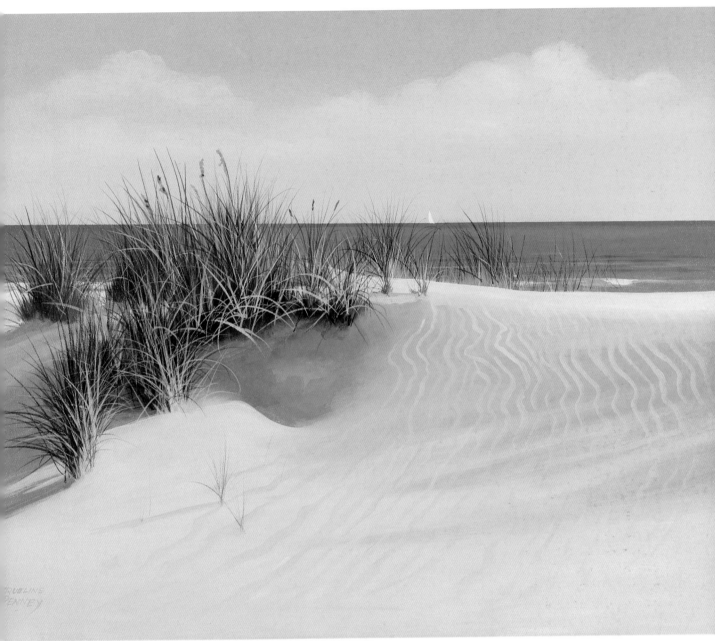

14 **GLAZE AND ADD THE FINISHING TOUCHES**
Use acrylic glazing liquid mixed with a little Yellow Ochre and go over the very light grasses. This will give them a yellow tint. Try adding Hansa Yellow with the glazing liquid and see what that does. To add a sailboat in the distance, use masking tape and cut out a small shape with one side slightly rounded and one side straight-edged (see page 58, step 12). Seal the edges with matte medium; when dry, paint two coats with Titanium White, then remove the tape. Place the sailboat between the two clumps of grass to tie them together. Add a few wisps of grass in the foreground.

LOOKING THROUGH THE DUNES
22" × 28" (56cm × 71cm)
Acrylic on canvas
Collection of Deborah O'Connell

Orient Point Energy

MATERIALS

PIGMENTS

Burnt Sienna

Burnt Umber

Cerulean Blue

Chromium Oxide Green

Cobalt Blue

Hansa Yellow

Mars Black

Phthalocyanine Blue

Phthalocyanine Green

Prussian Blue

Pyrrole Orange

Raw Sienna

Raw Umber

Titanium White

Ultramarine Blue

Yellow Ochre

BRUSHES

1" (25mm) flat

1½" (38mm) flat

No. 4 rigger

No. 4 round

OTHER

Acrylic glazing liquid

Hair dryer

Masking fluid

Masking tape

Matte medium

Medium-angled palette knife

Molding paste

Pencil

Rubber cement eraser

Straight palette knife

Toothbrush

Yardstick

Orient Point is at the tip of the north fork of Long Island where the ocean meets the sound. It has rocks of many sizes and is strewn with pebbles. A friend of mine managed to capture on film a wave crashing onto the rocks, splashing in midair, and I used the dramatic photograph to render a painting. How, you may ask, was I able to paint all those pebbles? I used a technique called *spattering* to create the pebbles in a painterly fashion that captures their essence; I did not paint each and every one.

Spattering

This technique can be a little messy, so I recommend that you place your canvas on several layers of newspaper on a large table where you will be free to spatter without doing any damage to the surrounding area. It will take time to spatter several layers of paint, and it is necessary to allow the paint to dry between layers so the spatters don't bleed into one another.

In this demonstration I introduce masking fluid. Watercolorists use masking fluid to preserve the white of the paper, and I did the same for this demonstration to create white pebbles. Masking fluid works just as well on stretched canvas.

For the sky, water and rocks, I used acrylic glazing liquid to slow down the drying process and allow more mixing time. I even used a finger to smudge the white in the clouds and soften the edges as if painting with oil paints.

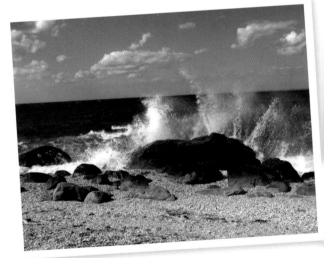

Reference Photo

Being in the right place at the right time, my friend captured this energetic wave splashing on the weather-worn rocks, a dramatic subject to paint.

ORIENT BEACH
Photo by Mario Tomiatti

"The sense of motion in painting and sculpture has long been considered as one of the primary elements of the composition."

—Alexander Calder

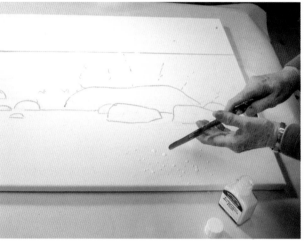

1 DRAW WITH A BRUSH
Use a watery consistency of a light blue-gray to delineate the simple shapes of the horizon, waves and rocks. It's not a good idea to put the horizon smack in the middle of your canvas. To make a straight line for the horizon, steady your brush on the edge of an angled yardstick, and glide it across.

2 SPATTER WITH MASKING FLUID
Lay the painting flat on a table that is protected with several layers of newspaper. You may want to cover the upper part of the painting to protect it. Masking fluid is a little like rubber cement, so use a palette knife instead of a brush (the knife will be easier to clean). Dip the knife into the masking fluid, angle it slightly downward, and tap the shaft on your other hand to shake off the droplets. As the fluid dissipates on the blade, tap a little harder to make smaller speckles. Allow the masking fluid to dry thoroughly before proceeding, or use a hair dryer to speed up the process.

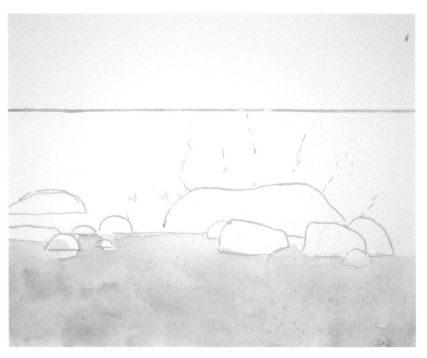

3 GIVE IT A WASH
When the mask is dry, wash over the beach area with a light, watery mixture of Cerulean Blue, Yellow Ochre and Raw Sienna with a large brush. Eventually, when the mask is removed, there will be a tint of color surrounding the droplets so they will stand out.

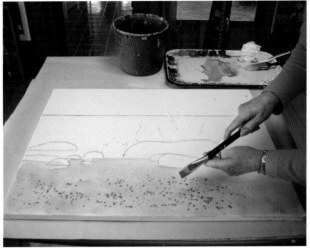

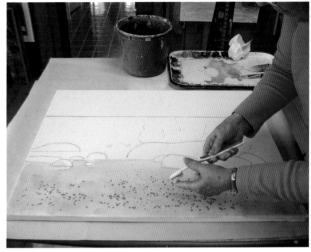

4 SPATTER WITH PIGMENT

The colors used for spattering are mixtures of Yellow Ochre, Raw Sienna, Raw Umber, Burnt Sienna, Hansa Yellow, Cobalt Blue and Titatnium White. Load a 1" (25mm) flat with watery pigment and tap the handle on your other hand, just as you did with the palette knife in step 2. You want the colors to range from very light to medium and not too dark. It will take time, because after several spatters the droplets will start to run into one another. A hair dryer will hasten the drying time.

5 USE A TOOTHBRUSH

A toothbrush can be used for spattering as well. The consistency of the paint should be on the watery side because it will not spatter if it is too thick. For tiny spatters, hold the tip of the toothbrush facing downward and flick the toothbrush with your finger to send a multitude of tiny flecks across a broad area. You can also load the toothbrush with paint and tap it on your other hand as you did with the palette knife and paintbrush.

Mixing Light and Dark Colors

When you want to make a medium to dark color, it's best to start with a dark color on your palette and add white to lighten it to the desired value. If you want a light color, start with white and tint it with color.

6 RUB IT OFF

Continue to spatter using almost white and tints of color until the foreground is covered with speckles. When you are finished with all the spattering and your canvas is dry, use a rubber cement eraser to remove the dry masking fluid (or rub it off with your fingers). The round, white pebbles will appear to "pop out."

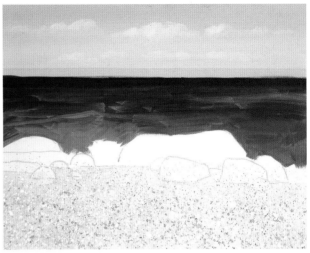

7 ADD BLUE SKIES

Begin with the upper sky, using Cobalt Blue mixed with a tiny amount of Pyrrole Orange to gray it down slightly. Mix in some acrylic glazing liquid to allow time to blend. Add Cerulean Blue and Titanium White as you paint downward to gray it down even more. As you approach the horizon line, add a tiny amount of Phthalocyanine Blue and Titanium White to your mixture to create a slightly greenish light blue. (Be careful when using the Phthalocyanine colors; they are very intense, so a little goes a long way).

With a 1" (25mm) flat, paint the clouds with Titanium White and a touch of Yellow Ochre. For the shadows underneath, mix a little Burnt Sienna with some of the blue you used previously. The cloud formations should become less intense as they approach the horizon. The wave is the focal point, so don't define the clouds too much; make them soft around the edges, smudging with your finger if necessary.

8 MARK THE HORIZON LINE AND PAINT THE WATER

I cannot emphasize enough how important it is to have a level horizon line, so re-measure and re-mark it on both sides before you begin painting the water. To make a very crisp line, apply masking tape and press it down firmly, then paint the tape with matte medium to seal the edges and let it dry.

The color of the water at the horizon line is quite dark, so you will need two coats of dark blue to cover the white canvas. Mix Ultramarine, Prussian and Phthalocyanine Blues with a little Mars Black and Phthalocyanine Green, and use the broad side of a 1" (25mm) flat for the first coat of paint.

Slow It Down

When painting a large area such as sky or water, add some acrylic glazing liquid to your paint mixture to slow the drying time. You will have more time to blend the colors, especially if you want soft edges.

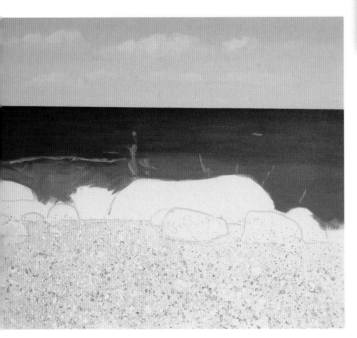

9 CREATE WAVE ACTION

Add a little more Phthalocyanine Green and a tiny bit of Mars Black to darken the blue mixture for the second coat. This time use the chiseled edge of a 1" (25mm) flat and paint horizontal strokes, adding and releasing pressure to create small swells in the water as you paint across the canvas. Make the color and value slightly different so the strokes show up. It is best to work across and then downward while your paint is still moist and workable (use acrylic glazing liquid to extend drying time). The large splashing wave will cover much of the water on the right, so just tint the blue slightly with Titanium White and paint over that area without too much detail. Establish where the wave and splashes will go with a little Titanium White.

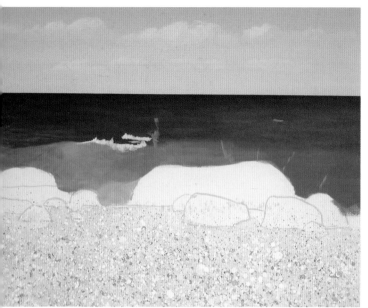

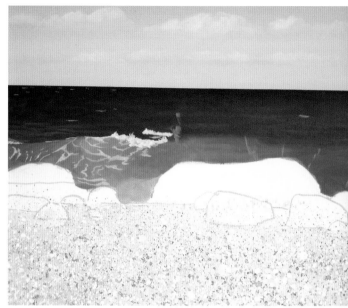

10 DEFINE THE CRESTING WAVE

Tint Chromium Oxide Green with Titanium White and add a little Phthalocyanine Blue and Mars Black to tone it down slightly, then paint the wave crest. There are several slight value changes within the crest: the colors change from green to a blue-green. Experiment with your colors by mixing different blues into your green mixture. Begin defining the crest of the wave as it splashes over the top using Titanium White. Two coats of Titanium White will be needed to cover over the dark blue to make it a bright white.

11 PAINT THE ZIGZAG SHAPES

The foamy backwash areas are small zigzags. Paint them with the tip of a no. 4 round, adding Titanium White to the mixture you used for the wave to make it a light gray-green. Use the very tip of the brush to gently stroke in tiny waves that can barely be seen in the distance.

12 DRYBRUSH THE SPLASH

Load Titanium White onto a dry 1" (25mm) flat brush. Rub some of the paint off onto a paper towel or piece of paper. With the flat of the brush, gently scrub the white that remains on the brush in fan-shaped strokes to create the almost transparent wave splash. The more pressure you put on the brush, the more pigment will be released. Conversely, if less pressure is used the paint will be diffused and almost have the look of pastel chalk. Use less pressure for the areas where you want to keep soft edges. For the finer spray, use a toothbrush to spatter pure white droplets.

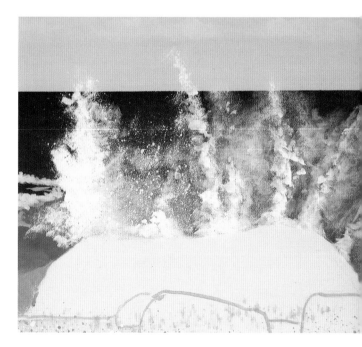

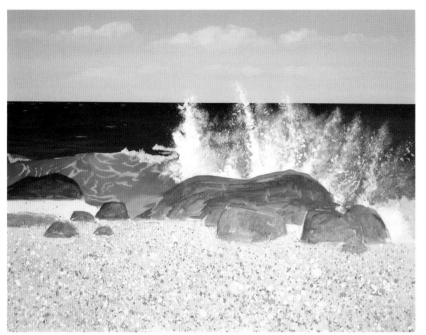

13 SPATTER, SPATTER

Finish spattering the rest of the water spray before you paint the rocks. Wipe off any errant spatter with a damp paper towel. After the spatter dries, use acrylic glazing liquid or matte medium mixed with blue-green pigment to go over some of the spatter on the right side of the spray that is in shadow.

Paint the rocks with a first coat of medium brown, just to cover the white canvas so you can see the subtle values of the rocks.

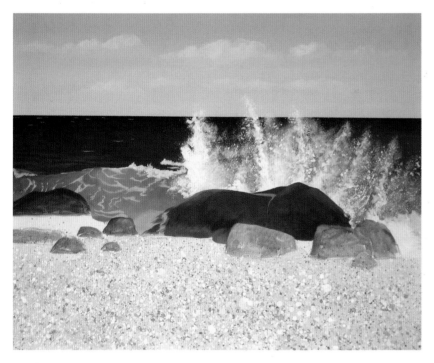

14 SCULPT THE ROCKS

The local color of the rocks is brown, but browns can be made more interesting by adding other colors such as blue, green, purple, red, black, etc., and the mixtures can be made lighter or darker. Think of the rocks as being sculpted, and make each facet a slightly different value and color than the one next to it. These rocks are rounded from the pounding of waves, which makes them less threatening than jagged rocks would be.

Logically there could be a puddle on the largest rock, created by the splashing wave. Even though it isn't in the photograph, you can add it as a small "eye-catcher" in an otherwise dark area. A little puddle on the rock would be like a mirror and reflect the sky color. To do this, just paint a pale blue-gray circular pool on the top of the rock and make it appear to drip downward.

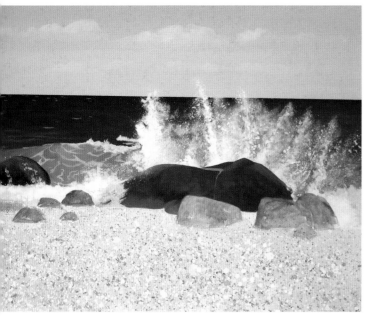

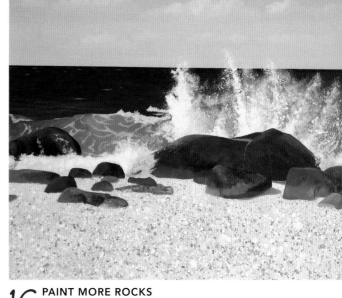

15 ADD MORE SPLASHES
Now that the large rock is completed you can add the spray of water to its left. Leave a little dark area to show that the rock can be seen underneath the splash. Repeat the same process you used for the large splash, employing the drybrush method and a toothbrush for spatter. The water should come in front of the rock to create a feeling of depth.

16 PAINT MORE ROCKS
The small rocks are not as wet as the large ones, and they have slightly lighter values. Although subtle, they show distinctive light and dark sides. Paint them with combinations of Raw Umber, Burnt Umber, Raw Sienna, Mars Black, Titanium White and blue. Use a no. 4 round to block in the colors and smooth some of the interior edges with acrylic glazing liquid or matte medium (or just use your fingers to smudge while it is still wet). The sunlight is coming from the left, so paint shadows to the right of the rocks. Adjust the shapes of the lower edges of the rocks where they meet the pebbles.

17 COMPLETE THE ROCKS
Finish the rocks and paint the area where the water meets the pebbles on the right side. Make any adjustments needed, such as adding more spatter. Lighten the blue puddle on the large rock and place shadows to the right of the rocks using Cobalt Blue, Titanium White and a little Mars Black to gray it down. Using the tip of a no. 4 round, dot in tiny pebbles at the base of the rocks.

Calligraphy

Calligraphy is generally applied to writing but may also be used as a painting technique. Using arbitrary brush-strokes to suggest something rather than defining it allows the viewer to interpret what the strokes mean while giving life to an otherwise dull area of a painting.

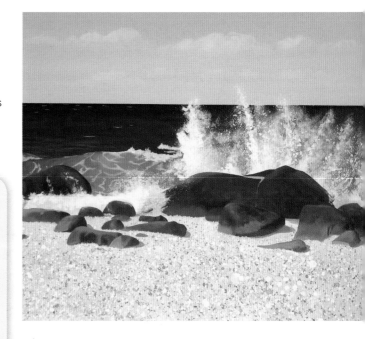

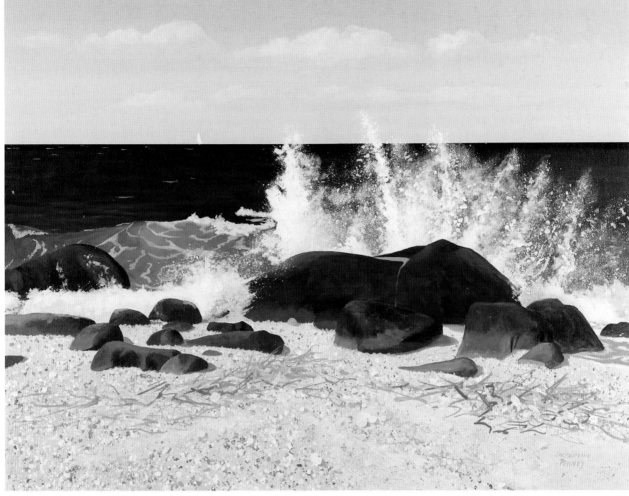

18 ADD THE FINISHING TOUCHES

With a mixture of Titanium White and Yellow Ochre, paint sandy areas that form arrow-like shapes to break up all the monotonous pebbles and lead the eye into the painting from the edge of the canvas. The heavy spattering shows underneath the brushstrokes, so use a palette knife to mix molding paste with Titanium White and Yellow Ochre and create ripple shapes over them. When dry, use a toothbrush to spatter over the sandy area with Titanium White and browns to give it a granular feeling.

Use a no. 4 rigger to make calligraphic strokes on the beach in blue-gray for shadows. Then use a medium-size rigger and/or a small round to make squiggles and linear shapes with Raw Sienna, Yellow Ochre and Burnt Sienna to suggest natural debris. No man-made trash, please.

Make comma-like shapes to the right of several larger pebbles on the beach to create their shadows.

For the sailboat, cut a straight edge about ½" (13mm) long on a small piece of masking tape and then make a rounded cut to the left and join the cuts at the bottom (see page 58, step 12). Seal the edges of the tape with matte medium and give it two coats of Titanium White paint. Remove the tape when the paint is dry, and you will have a sail that looks like it is billowing out to the left and is slightly keeled over, suggesting a strong wind.

To create the tiny waves in the distance, rest a no. 4 rigger loaded with Titanium White on a yardstick (see page 39) and make small, unevenly placed dashes across the water.

ORIENT POINT ENERGY
22" × 28" (56cm × 71cm)
Acrylic on canvas

Protect Your Paintings

It is wise to protect your paintings with a final coat of varnish. Golden Artist Colors suggests using two parts of their Soft Gel (Gloss) Medium to one part water. Fill a measuring cup with two-thirds gel and one-third water to make one cup of varnish. Mix thoroughly and apply evenly with either a 1½" (38mm) flat bristle brush or an inexpensive foam brush that can be purchased from a hardware store or craft shop. Seal the remainder in a tight jar for future use.

Low Country

MATERIALS

PIGMENTS

Burnt Sienna

Cadmium Red

Cerluean Blue

Chromium Oxide Green

Cobalt Blue

Dioxazine Purple

Hansa Yellow

Mars Black

Prussian Blue

Pyrrole Orange

Quinacridone Magenta

Raw Sienna

Raw Umber

Yellow Ochre

Titanium White

BRUSHES

¼" (6mm) flat

½" (13mm) flat

1" (25mm) flat

1½" (38mm) flat

No. 8 rigger

No. 6 round

OTHER

Acrylic glazing liquid

Hair dryer

Masking tape

Matte medium

Pencil

Ruler

White chalk

I gave a workshop in Spring Island, South Carolina, which is located very close to Savannah, Georgia. The "low land" of the Spring Island savannah is subtropical, lying on the margin of the trade wind belts. At low tide some of the areas become mudflats, and at high tide the water "seeps" into the area, flooding it. I always take my camera wherever I go, and I was able to get some good photographs of this lovely place.

The sky isn't very interesting in the photograph, so I added more clouds in my painting of the scene. I made the large thunderheads small to create the illusion of depth. Drybrushing is a good technique to use when painting clouds. I think of billowing clouds as bunches of cotton with a light shining on them that creates shadows below and to the side. It isn't obvious in the photograph where the sun is, so I painted as though sunlight was coming from the right.

I know that there is a bay way off in the distance, so even though it doesn't show up in the photograph, I painted a long sliver of blue to stress the strong horizontal motif of the painting in the distance.

It was obviously low tide when I took this photograph showing the small water rivulets snaking back out toward the sea. I was interested in the beautiful patterns of the grasses in the foreground and didn't care where the tide was. So for this demonstration, I made it "high tide" just to show you that the artist can even affect the tides.

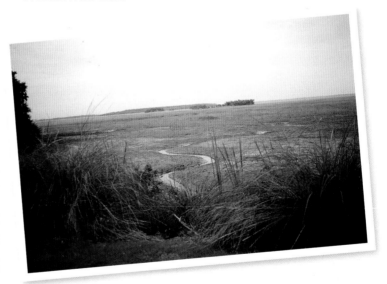

Reference Photo

Look carefully—the crisscrossing of grass blades creates the beautiful triangular negative shapes. There is a wide range of values from very dark to light.

1 PAINT JUST A FEW LINES

A few lines painted with Yellow Ochre are all that you need to interpret this photograph's composition and develop it into a painting. To locate the horizon, measure down from the top of the canvas 7½" (19cm) on both sides and draw a straight line across using a ruler. The distant water is very far away and must be perfectly level.

2 MAKE YOUR OWN SKY

With a 1½" (38mm) flat, mix Cobalt Blue with a tiny bit of Pyrrole Orange to gray it, and begin working downward. About halfway down, mix in Cerulean Blue with a tiny bit of Pyrrole Orange and Titanium White to lighten it. Use long horizontal strokes and bring the pigment a little over the horizon line. While the sky is still wet, switch to a 1" (25mm) flat and add cloud formations. Mix Titanium White with a tiny bit of Yellow Ochre and deep red made from Cadmium Red and Mars Black to tint the white and give the clouds some warmth. Use a mixture of blue, Titanium White, Raw Sienna and Dioxazine Purple for the shadows underneath and to the left of the clouds. Use the drybrush technique to create soft transitions of values and colors.

Level Horizons

Even when you fill a glass with water and tip it slightly, the water will always remain level. Large bodies of water are contained by land mass and seek their own level as well. A common mistake is to make the horizon line tilted; even if the painting is done well, it will always look askew. I suggest measuring down from the top of the canvas on both sides, then using a ruler to draw a line from one mark to the other to ensure a level horizon line.

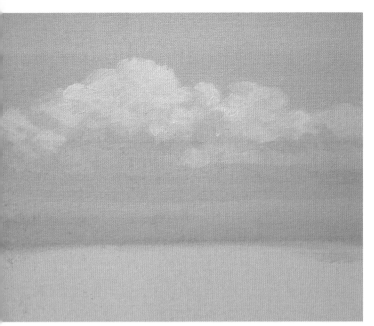

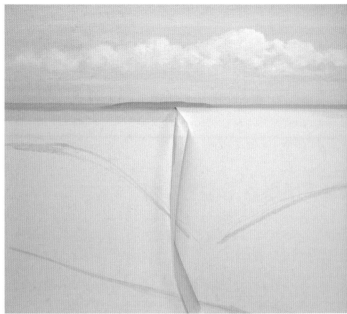

3 FINISH THE CLOUDS AND THE SKY

Wait for the paint to dry or dry it with a hair dryer to see its true coloring. With a ½" (13mm) flat, mix Titanium White with a tiny bit of Yellow Ochre and Quinacridone Magenta to make the clouds a little warmer. Continue painting the billowing clouds with tiny dabs in a circular motion. The beauty of acrylic paint is that you can always go back and work on the sky until you are satisfied with the results.

4 PAINT THE DISTANT LAND

Measure 7½" (19cm) down from the top of the canvas again to mark exactly where the horizon line is and pencil it in with a ruler. To make a crisp horizon line, place masking tape on your pencil line. Create a medium-light value with a mixture of blue, red and a little Yellow Ochre and paint the distant land. Darken the mixture and paint the small island that is a little closer.

5 PAINT THE DISTANT WATER

When the distant land is dry, place a piece of masking tape over it, making sure the edge of the tape is exactly on the pencil line. To make a very crisp line and prevent the paint from running underneath the tape, paint the edge of the tape with matte medium to seal it, then dry it with a hair dryer and paint the distant water a vivid blue.

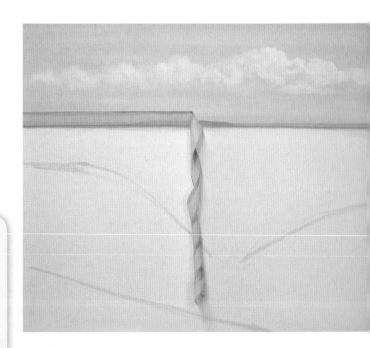

Take It All In

Get in the habit of looking at your surroundings. Notice how the sky looks with clouds and without them. Pay attention to the location of the sun and take note of where shadows appear. If you look straight up on a clear day, the sky will be very blue, but the blue will be less intense as the sky meets the land. So when you paint a sky, make it lighter and more diffused as it meets the earth.

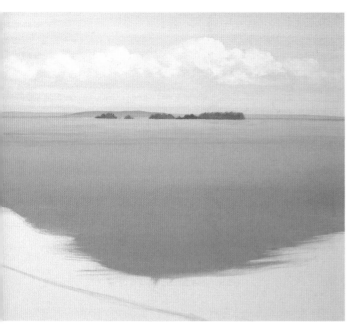

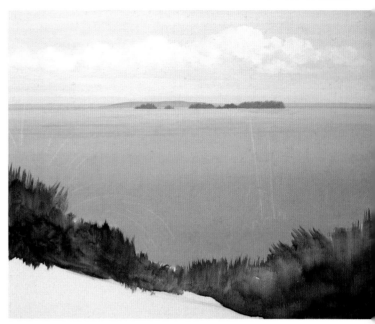

6 WORK YOUR WAY UP

Mix a combination of Cobalt Blue, Prussian Blue, a tiny bit of Mars Black and just enough Titanium White to lighten the color to a medium dark. Paint the water with a 1½" (38mm) flat, beginning near the grassy area in the foreground and working your way up. Use even, horizontal strokes, and add Titanium White to lighten the value of the water as it nears the land. Let the area dry, or dry it with a hair dryer.

With a 1½" (38mm) flat, paint the distant yellow marshland with a mixture of Yellow Ochre, Hansa Yellow, Raw Sienna and Titanium White. If the mixture is too yellow, add a tiny bit of Dioxazine Purple to gray it down. Rest your brush on an angled ruler to keep a crisp line (see page 39). As you near the water, don't replenish the paint on your brush; use the drybrush technique to blend the colors, creating soft edges to suggest that there is grass in the water.

With a ¼" (6mm) flat, mix a variety of medium-to-light earth colors and stipple the tiny clumps of trees and foliage in the distance. I used an old brush with splayed bristles to create little patterns in the bushes.

7 UNDERPAINT THE GRASS AREA

Use a piece of white chalk to re-establish where the foreground grasses are. To paint the dark area underneath the grasses, mix Burnt Sienna, Raw Umber and Prussian Blue to make a rich dark, and apply it with a 1½" (38mm) flat using sweeping upward motions to simulate the grass shapes. The paint should be a little watery. You do not want hard edges that will show through when you paint the grasses. Use a mixture of Chromium Oxide Green, Raw Umber and Yellow Ochre to paint the short grasses in the middle.

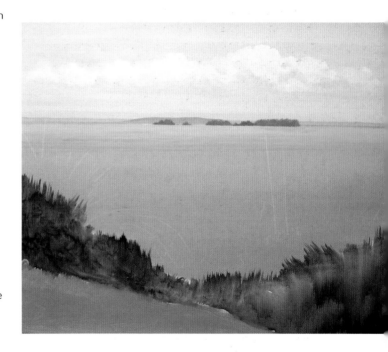

8 COVER UP DISTRACTIONS

A large white area on the canvas can be distracting. Use a medium value of green to cover it and to make it more proportional to the rest of the painting. Now it will be easier for you to see colors and values.

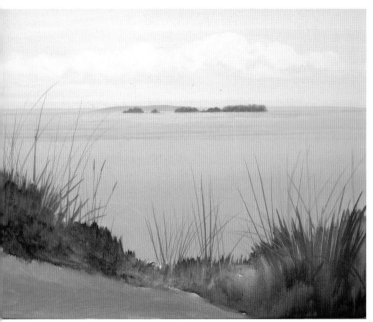

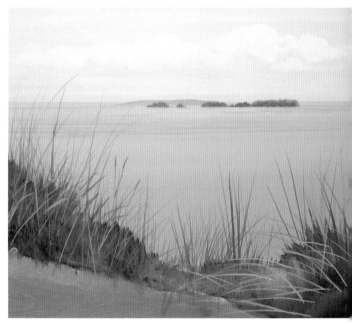

9 PAINT THE GRASSES

You can see from the photograph that the grasses standing straight up are either green or orange-yellow. With a ½" (13mm) flat, mix Chromium Oxide Green with a little Raw Umber, Yellow Ochre and Titanium White and stroke upward with the edge of the brush to paint the shorter grasses and to cover the brown underneath. Elongate the green grasses with a no. 8 rigger, using enough water to make the paint flow smoothly. For the yellowish grass, use earth colors mixed with yellows and Titanium White. Brush them in with a sweeping upward motion, crisscrossing some of the blades. Extend some of the grasses up and over the distant marshland to give the painting a feeling of depth.

10 BEND THE GRASSES

Continue adding the green and yellow grasses by making sweeping curves with a no. 8 rigger.

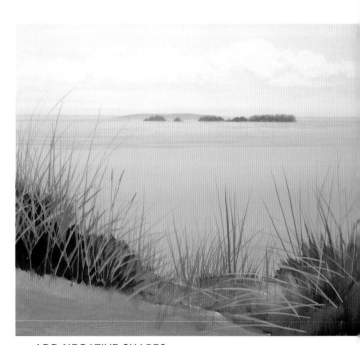

11 ADD NEGATIVE SHAPES

Re-establish the dark interior of the grasses on the left. Mix several dark pigments such as Burnt Sienna, Raw Umber, Chromium Oxide Green, Cadmium Red and a little Mars Black to get a rich, warm dark. Paint the triangular negative shapes between the grasses.

Mix It Up

Painting one color is boring, so mix a slightly different variation after a few strokes. This palette shows the variety of greens used just for the small segment of short grasses. Use all the colors on your palette and experiment to see how many different greens you can create.

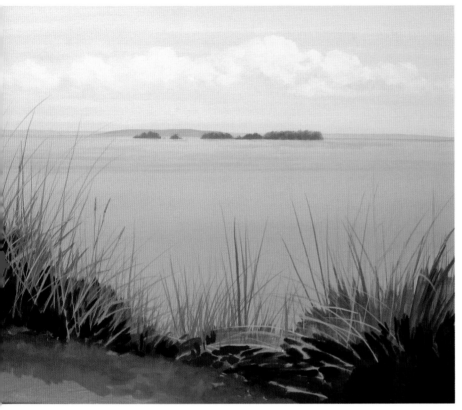

12 INTENSIFY THE DARKS
For the very dark area under the short green grasses in the middle and the long yellow grasses on the right, mix Burnt Sienna, Raw Umber, Cadmium Red and a little Prussian Blue to make a very deep, dark, warm color. Use a ½" (13mm) flat to make small dabs, flipping your brushstrokes upward in the direction of the grasses. You want to create a grassy feeling without painting the grass in detail.

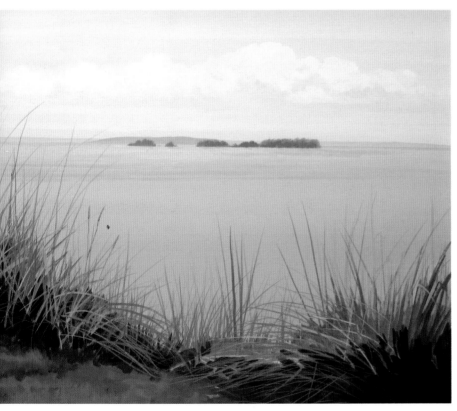

13 BALANCE THE VALUES TO CREATE DEPTH
Add more blades of grass in the darkest areas with a medium-dark shade of brown. There is little contrast because they are in shadow, but, quiet as they are, they still give the illusion of depth.

14 ADD MORE GRASSES AND NEGATIVE SHAPES

The overlapping of green and yellow grasses builds the clumps of grass and brings them forward. Continue painting the grass blades and the negative shapes between the grasses until you are satisfied with how that area looks.

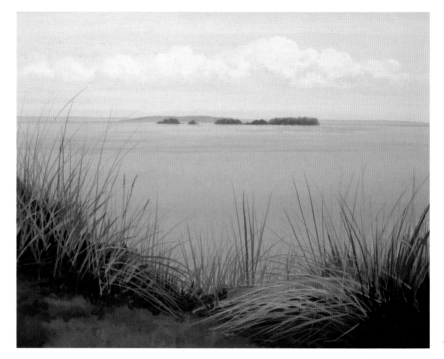

15 GLAZE

To darken the light grasses on the right side, glaze over them with a dark, warm brown mixed with acrylic glazing liquid or matte medium. Let the canvas dry after each application.

Fill in more triangular negative spaces with warm darks if necessary. Use a no. 6 round to paint the light-green grasses coming toward the viewer on the far right. Start at the top of the grass and put pressure on the brush to splay it out slightly. As you stroke downward, release the pressure so only the tip of the brush is touching the canvas near the end of the stroke, creating a pointy blade of grass. This will create the illusion that the grass is coming forward.

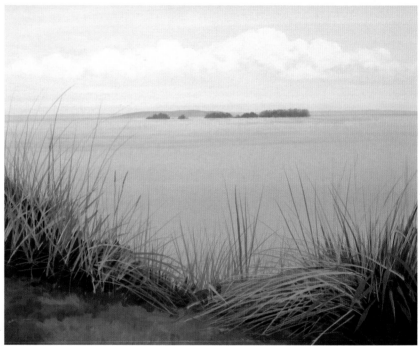

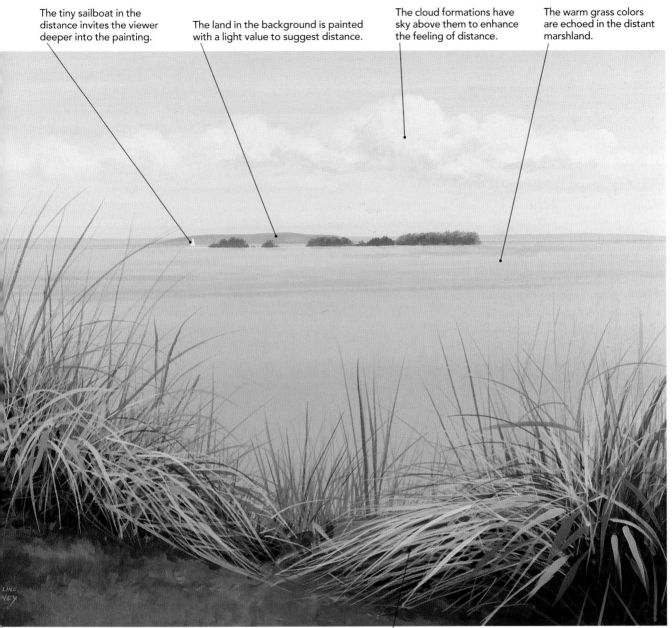

The tiny sailboat in the distance invites the viewer deeper into the painting.

The land in the background is painted with a light value to suggest distance.

The cloud formations have sky above them to enhance the feeling of distance.

The warm grass colors are echoed in the distant marshland.

Overlapping the grasses creates small triangular shapes within, adding depth.

LOW COUNTRY
22" × 28" (56cm × 71cm)
Acrylic on canvas

16 ADD THE FINISHING TOUCHES

Paint the grasses on the left side of the canvas just as you did the grasses on the right side, adding more blades, glazes and negative shapes.

Look over the painting and make adjustments to anything that needs to be developed further, such as the clouds. Add more light-yellow and light-green grasses on both sides. Paint a tiny sailboat in the distance (see page 58, step 12).

Wednesday

MATERIALS

PIGMENTS

Burnt Sienna

Cadmium Red

Cadmium Yellow Primrose

Cerulean Blue

Chromium Oxide Green

Cobalt Blue

Dioxazine Purple

Hansa Yellow

Hooker's Green

Mars Black

Phthalocyanine Blue

Phthalocyanine Green

Prussian Blue

Pyrrole Orange

Quinacridone Magenta

Raw Sienna

Titanium White

Yellow Ochre

BRUSHES

½" (13mm) flat

1" (25mm) flat

Nos. 2 and 4 rounds

OTHER

Acrylic glazing liquid

Hair dryer

Head magnifier

Masking tape

Matte medium

Pencil

Plastic wrap

White chalk

Just a few minutes away from my studio, my eyes can feast on beautiful scenes year-round. I love to paint them in all seasons but decided to do this painting in luscious fall colors with full growth. I titled the painting *Wednesday* because there are sailboat races around Robins Island nearly every Wednesday of the year. Robins Island is a small, privately owned island in Peconic Bay, and I am grateful to the owner for keeping it natural and full of wildlife.

I wanted to paint this scene on a grand scale, so I purchased 30" × 40" (76cm × 102cm) heavy-duty stretcher bars with a bracket to reinforce the center and prevent the canvas from warping when it is stretched over and around the bars. I used unprimed heavy-duty duck canvas and primed it with two coats of gesso. After each application of gesso, I lightly sanded the canvas with medium-grit sandpaper. The canvas became even more taught as the gesso dried, shrinking slightly to create a very satisfactory ground.

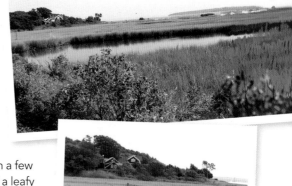

Reference Photos

I used the top photo as reference for my painting. If you look closely you will see where I have elongated it on the right side using Adobe Photoshop.

The bottom photo was taken a few feet away. It shows a closeup of a leafy bush and a wild plant that produces berries in the fall. I love the patterns and details, and the light-blue berries in the foreground echo the sky color.

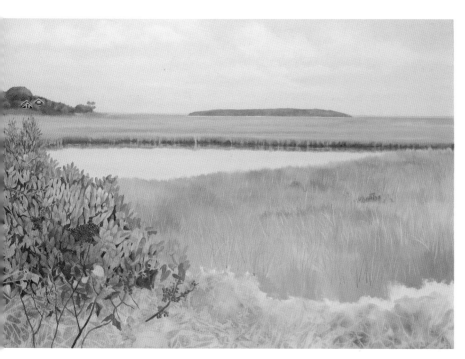

A Painting in Progress

This demonstration focuses on how to create an interesting underpainting and how to see and paint negative shapes.

Use what you've learned in the previous demonstrations to complete the sky, water and marshland before you begin the underpainting of the detailed bushes. Use my unfinished painting to the left as reference.

1 BEGIN THE UNDERPAINTING
To show how the underpainting was done for the leafy area, this technique is demonstrated on a canvas board. Apply very watery greens, yellows, oranges and blues with a 1" flat as shown.

2 APPLY CRUMPLED PLASTIC
Before the paint dries, place crumple plastic wrap over it and press down to create interesting patterns.

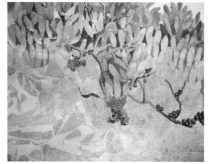

Closeups of the Underpainting

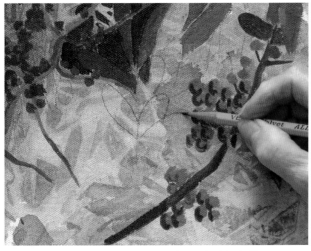

3 BEGIN DETAIL BY DRAWING LEAF SHAPES
Use a pencil to draw the positive shapes of the leaves.

4 PAINT AROUND THE LEAVES
This lost-and-found technique is mostly used in water-color. Paint around each leaf with a slightly darker color, then use a wet brush or acrylic glazing liquid to wash the pigment away from the leaf so there is no longer a hard line but more of a value change from dark to light. Also paint the negative shapes between the leaves with darker colors, such as dark greens, browns and reddish hues.

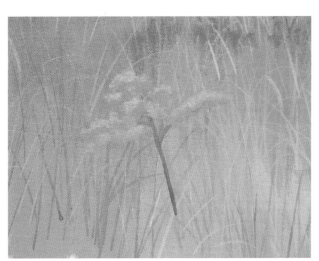

5 ADD THE RAGWEED
Research wildflowers for a photograph of ragweed, which has a lovely sunny yellow color. Because yellow is the lightest color on the color wheel, you'll need to use one or more layers to cover over the background. Mix Cadmium Yellow Primrose and Hansa Yellow together with a little Titanium White and use an old brush with splayed bristles to stipple the flower shapes of the ragweed. Add a little Yellow Ochre and Raw Sienna to make a slightly darker shade for the underside of each blossom. This is all very subtle, but it makes a big difference. Notice that the stem is not just one color. Use a light yellow-green near the top and then mix that with Burnt Sienna as you paint down the stem.

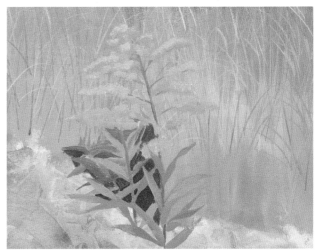

6 CONTINUE ADDING BLOSSOMS AND LEAVES
Crisscross the larger leaves on the left, starting with the ones in the background and overlaying lighter green leaves on top. To bring them forward, paint the negative shapes around and in between the leaves. Mix several different greens, using colors such as Hansa Yellow and Yellow Ochre, Raw Sienna and sometimes Burnt Sienna and reds to gray it down.

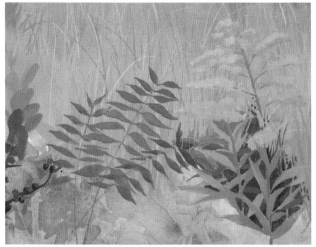

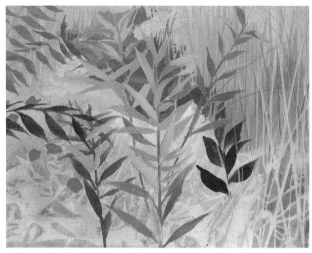

7 PAINT MORE LEAVES AND VERTICAL GRASSES

Add vertical grasses underneath and then paint more leaves on top. For variety, use a different kind of plant with fatter, evenly shaped leaves. Make the stems curved instead of straight up and down like the grasses beneath. Create a medium green mixed from Burnt Sienna, Hansa Yellow and a little Titanium White and apply it opaquely. Because the space underneath is lighter, the opaque leaves stand out. Think about light over dark and vice versa, keeping in mind the values that will give you the most contrast.

8 ADD CRISSCROSSING LAYERS

Paint another blossom of ragweed behind the leaves, and add a stem and more positive leaves. Then paint some redish-pink blossoms of what could be a wildflower. Although not a focal point, the blossoms will add some color to the green foliage. Paint more varieties of positive leaves and use a rigger brush to make long, crisscrossing blades of grass with mostly white pigment. The crisscrossing grasses create triangular negative shapes that you can fill in with a light green-yellow to make the grasses stand out.

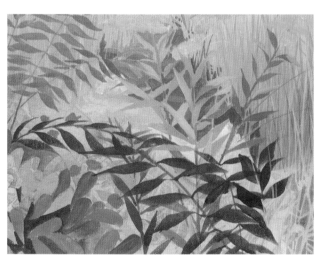

9 OVERLAP AND OVERLAY

Continue overlapping and crisscrossing more leaves. Draw the leaves with a pencil so you can see where to paint the positive and negative shapes.

Many artists feel uncomfortable overlapping areas because they are afraid to change something by painting over it. But the overlapping creates interest and the illusion of depth.

10 GLAZE THE DETAILS

You can see the slightly yellow glaze I brushed over the almost-white blades of grass to give them a yellow tint. Throughout the entire painting, you should concentrate on these opposites: positive/negative, warm/cool, large/small, transparent/opaque, near/far—and in each case make an effort to bring forward or push back objects that will give the painting interest and depth.

11 PAINT THE QUEEN ANNE'S LACE

Fill in the elongated angular shapes between the grasses with a light green, and define the larger leaves on the lower right. Load a small splayed brush with Titanium White and stipple the heads of the Queen Anne's lace. Go over it a few times to make sure the white covers the paint underneath. Google Queen Anne's lace for several reference photos. The leaves are thin, and the stem is not straight but kind of wiggly. Make the blossoms face different directions and vary their sizes to show that they are in different stages of development. Place tiny white and yellow shapes in the background to let the viewer know there is more Queen Anne's Lace and ragweed in the distance.

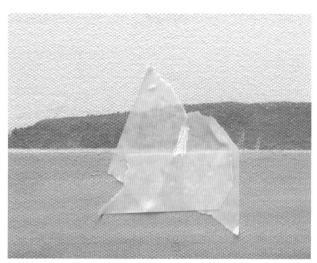

12 CREATE A DISTANT SAILBOAT

Place three pieces of masking tape firmly on the canvas to create a small triangle shape. Seal the edges with matte medium so no pigment can leak underneath. When dry, paint over the shape with two coats of Titanium White, then remove the tape.

13 ADD MORE SAILBOATS AND PAINT THE SAND

Continue painting tiny sailboats along the water, varying their sizes slightly. Paint two little sandy areas on the grassy beachfront with a combination of Yellow Ochre and Titanium White.

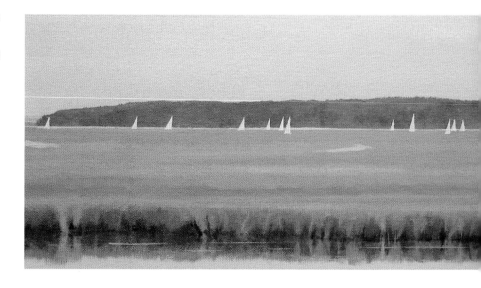

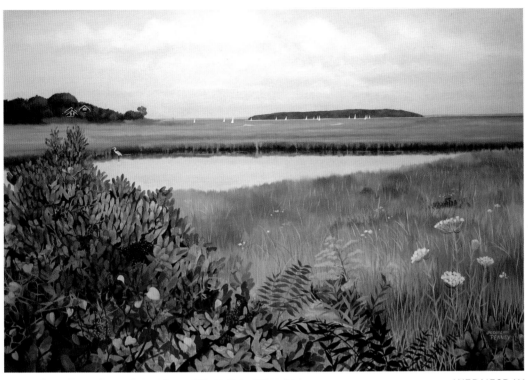

WEDNESDAY
40" × 60" (102cm × 152cm)
Acrylic on canvas

Using a Head Magnifier

This handy tool slips onto your head like a cap so you can easily view intricate details or small areas of your paintings. For *Wednesday*, I used it to magnify the Great Blue Heron near the reedy grasses, as well as his reflection on the still water. You might want to use a head magnifer to help you with the details of this painting, such as the tiny sailboats or the house that sits in the distant trees.

A Day at the Beach

MATERIALS

PIGMENTS

Burnt Sienna

Cadmium Red

Cerulean Blue

Chromium Oxide Green

Cobalt Blue

Dioxazine Purple

Hansa Yellow

Mars Black

Pyrrole Orange

Raw Sienna

Raw Umber

Titanium White

Ultramarine Blue

Yellow Ochre

BRUSHES

½" (13mm) flat

1" (25mm) flat

1½" (38mm) flat

Nos. 2 and 8 riggers

No. 2 round

OTHER

Acrylic glazing liquid

Masking tape

Matte medium

Pencil

Ruler or Yardstick

Toothbrush

Tracing paper

Transfer paper

I'm sure you can conjure up a day at the beach: the sound of waves crashing and seagulls cawing, a lovely breeze and a little shade from a planted umbrella, and maybe a good book to read.

All man-made objects put in a picture frame are subject to constraints, such as relationships to surrounding objects and perspective. These objects need to be exactly represented. Therefore, I do all the drawing of these man-made objects on tracing paper to make an interesting composition. A beach bag will be a nice touch after painting the chair, and it tells the viewer that someone has staked this lovely spot out for themselves. The umbrella is purposely cut off at the edge and is made large enough to go over the halfway mark. The nearby grassy area will balance the man-made structures. I will attach tracing paper to the back of my canvas, pull it forward and do all the drawing there, keeping my canvas clean and ready to paint the large areas such as sky, water and sand without the hardship of painting around objects.

1 DO A PRELIMINARY DRAWING ON TRACING PAPER

Make a color copy of my completed painting, trim all the edges and divide into sixteenths. It's a perfect square, so measurements should be easy; if you have trouble, just fold the paper into sixteenths and draw lines on the folds. Repeat the grid on the tracing paper that is attached to your canvas and draw the horizon line and the waves. Then draw the umbrella and chair accurately, referring to the grid lines, and draw simple lines that suggest the other shapes.

(The dark cross in the middle of the paper is there to align my camera).

Use Your Camera

When you are looking for things to paint for a beach scene, go to a store where they sell summer outdoor furniture. I'm sure you will find things such as beach chairs and umbrellas. Photograph the things you are interested in from several angles and heights, and keep them in a file for future use.

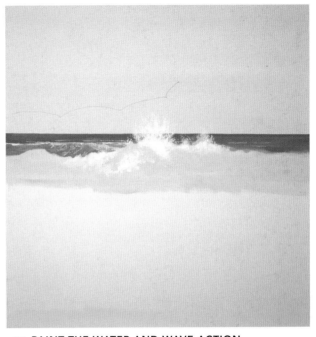

2 PAINT THE SKY

The horizon is 9¾" (25cm) from the top of the canvas. With a 1½" (38mm) flat, mix Cobalt Blue, Titanium White and a tiny bit of Mars Black and begin painting the sky. As you paint down toward the horizon line, add Cerulean Blue and a little more Titanium White. Near the horizon line, add a tiny bit of Pyrrole Orange and Titanium White.

3 PAINT THE WATER AND WAVE ACTION

Bring the tracing forward and place transfer paper between the canvas and the tracing paper. Trace only the lower edge of the umbrella to gauge where the splashes will end and where the waves are. Re-measure the horizon line and rest your brush on a tilted ruler (see page 39) to paint the horizon with a medium-dark blue-gray mixed from Ultramarine Blue, Cobalt Blue, Titanium White and a little Chromium Oxide Green. Paint the crest of the wave in back with tinted aqua and green. Use a light blue mixture to paint the large waves in front so they will show contrast when white is applied for the splashes. Drybrush the waves and then spatter Titanium White with a toothbrush. If necessary, dot in areas of white with the tip of a no. 2 round.

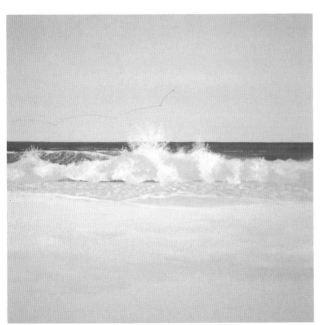

4 FINISH THE WAVE

Drybrush more white over the wave, adding slightly darker areas near the base of the wave to create volume. Paint the foamy water that nears the beach with pure Titanium White, using the tip of a no. 2 round to paint the squiggly lines. Add a little tan beneath the wave to indicate the possibility of some rocks or coral. Paint the beach using a lot of Titanium White mixed with Yellow Ochre to cover the white of the canvas. Use different values and shades of that color to give the sand some subtle texture. Add a flat light-blue area to represent the receding wave that reflects the sky.

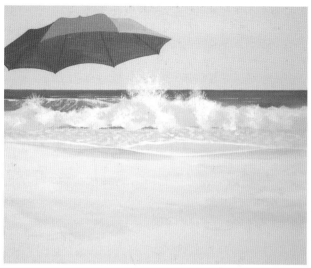

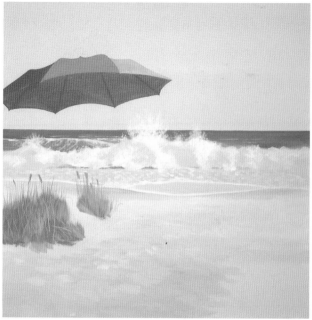

5 PAINT THE UMBRELLA

Lightly trace the rest of the umbrella. Combine Pyrrole Orange, Cadmium Red and a little Mars Black, Titanium White and blue for the underside of the umbrella, and carefully paint the whole area. The spine structure is slightly darker and not hard-edged. Brush the spines in with the edge of a ½" (13mm) flat with a darker version of your color mixture. For the top, use Pyrrole Orange, Cadmium Red, Titanium White, a little Hansa Yellow and a tiny bit of Mars Black and mix a medium value. The top right of the umbrella will be the lightest value; the middle area will be the local color of the umbrella, and the left side will be in the shade and darker. Mix a large portion of the basic umbrella color. Take a portion of that away and mix it with Titanium White to make a light value and paint the right side of the umbrella. Then take a portion of the original color and add Mars Black and/or a little blue to darken it and paint the two remaining sections, one with the original mixture and one that has been darkened. Add more blue areas to the water's edge and darken the sand to make it look wet.

6 BEGIN PAINTING THE GRASSES

To see where the chair is and where to paint the grass, bring the tracing to the front of the canvas and lightly trace an outline of the chair. Repaint the beach area with very light pastel colors, blending while still wet (use Titanium White last). Use a 1" (25mm) flat with a mixture of Chromium Oxide Green, Raw Sienna and Titanium White to paint the grass area with upward strokes. Then use a no. 2 rigger to extend the blades of grass. Change the color and value several times so there is a variety of green shades. Add some heads to the grass tops. Add white blades of grass; when dry, glaze them with Yellow Ochre and a little Pyrrole Orange.

7 ADD THE UMBRELLA POLE AND CHAIR

Bring the tracing back to the front of the canvas. It is not necessary to draw the entire pole; just mark the top and bottom. On the canvas, tape from mark to mark and paint the pole a brownish color. Make it slightly darker on the left side, and use your finger to smudge the two values in vertical strokes. When the canvas is dry, bring the tracing back and trace the outline of the chair. The back of the chair is in the shade and should be a blue-gray with a tiny bit of orange to give it warmth from the reflected grass. Use masking tape to seal the side edges and paint the back of the chair a solid color. Dry and tape the two side edges and paint them pure Titanium White. Carefully paint the rounded top freehand. With a similar blue-gray of the chair back, paint the left leg and show the sun hitting the bottom with Titanium White.

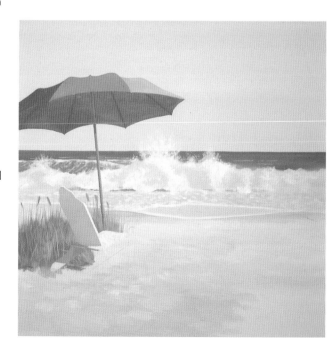

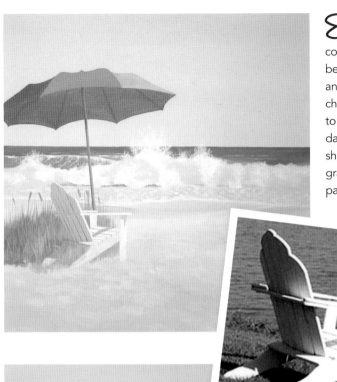

8 FINISH THE ADIRONDACK CHAIR

Paint the seat with several coats of Titanium White to cover the green grass. Add more grass under the seat and between the back legs of the chair. Bring your tracing forward and trace the lines of the slat openings on the back of the chair. Turn the canvas on its side and use a ruler or yardstick to steady the brush and paint the slat openings with a slightly darker blue-gray, then turn the canvas back and paint the shadow and slat openings on the seat with a medium blue-gray. Mask areas of the seat where you want crisp edges, and paint the sunlit areas and the shady areas blue-gray.

Reference Photo

This photograph shows the sun coming from the right, which will work well for this painting.

9 ADD THE BEACH BAG

Paint a small light-orange beach bag next to the chair and add more grass on the side of the chair and over the bag. Use a variety of greens for the grasses and pull them upward with a no. 2 rigger. Each time you overlap, you create depth in the painting. Mix a little Yellow Ochre and Titanium White to paint the sand across the bottom of the grass, and extend it into the grass in several places. Use a no. 2 rigger to paint white blades of grass. Dry the area and then glaze the white grasses with Hansa Yellow.

Turn Your Canvas as Needed

It's awkward to use a ruler or yardstick straight up and down when you need support. It's easier to turn your canvas sideways and then rest your brush on the tilted ruler to paint straight lines.

Dune Photograph
This picture was taken years ago and I
saved it on my computer under the head-
ing of *Water Scenes*. It makes a wonderful
reference photo to show what dune grass
looks like up close.

10 PAINT THE FOREGROUND DUNE

Paint several shades and values of
green grasses behind the dune. The
foreground dune and grasses are very
prominent because the dune is in the
shade; the colors will be quite dark and
in great contrast to the bright umbrella and chair. This will
balance the composition so it is not one-sided. Mix a warm
dark color from Burnt Sienna, Dioxazine Purple and a little
green. With a 1" (25mm) flat, paint the dark area and then
use the side of the brush to extend the shapes upward. Add
Titanium White to the mixture as you paint downward, and
mix several combinations of the light shadow color (which
could be considered "mauve") from yellow, orange, deep
red, purple and a little Mars Black. The value goes from very
dark to medium-light; if you can paint quickly, you can blend
the colors together to create soft passages (otherwise you
can use the drybrush method). As you develop this area,
there will be a lot of crisscrossing of colors, shapes and values
to construct a contrived mess of grasses.

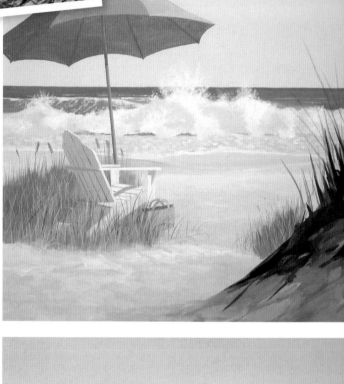

11 CRISSCROSS THE SHAPES

Introduce several shades of medium pastel colors over
the lower area. With a no. 8 rigger, sweep strokes upward
into the water and sky area. Use several different colors such
as Burnt Sienna, Raw Umber, Chromium Oxide Green, blue,
yellow, orange, purple, Yellow Ochre (and Titanim White
when needed to lighten) to make interesting color mixtures
and values. Some of the stems are quite orange, echoing the
color of the umbrella.

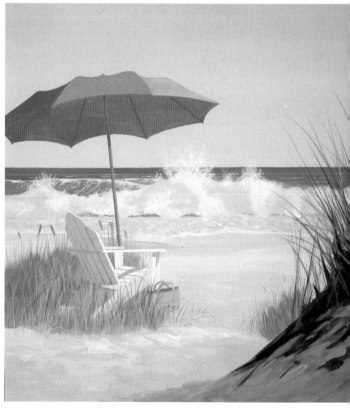

12 ADD THE FINISHING TOUCHES

Add more pastel colors to the sand and make it lighter near the base of the dune. Add more grass that goes even higher into the sky and paint tops on a few. Paint more stems over the dark area, some of them coming toward the viewer and a few in Titanium White. Mix Raw Sienna and Pyrrole Orange with a little Titanium White and use calligraphic strokes (see page 44) to create debris among the grasses. Try several different glazes over the dune grasses, and if you don't like the effect, wipe it away with a damp paper towel. Use a toothbrush to spatter the foreground beach area with gray-blue and white. Finally, add a little sailboat in the distance under the umbrella (see page 58). Clean any tracing smudges with soap and water. Let the canvas dry, then give the painting a protective coat of varnish mixed from two parts gel medium to one part water (see sidebar on page 45).

A DAY AT THE BEACH
24" × 24"(61cm × 61cm)
Acrylic on canvas

Two for One

MATERIALS

PIGMENTS

Burnt Sienna

Burnt Umber

Cadmium Red

Cadmium Yellow Primrose

Cerulean Blue

Chromium Oxide Green

Cobalt Blue

Dioxazine Purple

Hansa Yellow

Payne's Gray

Phthalocyanine Blue

Phthalocyanine Green

Pyrrole Orange

Quinacridone Magenta

Raw Sienna

Raw Umber

Titanium White

Ultramarine Blue

Yellow Ochre

BRUSHES

½" (13mm) flat

1" (25mm) flat

No. 4 rigger

Nos. 4 and 6 rounds

¼" (6mm) splayed flat

4" (10cm) sponge brush

OTHER

24" × 24" (61cm × 61cm) luan board

Acrylic glazing liquid

Gel medium

Gesso

Masking tape

Pencil

Radial saw

Sandpaper or electric sander

Toothbrush

Tracing paper

Transfer paper

Yardstick

White Chalk

My print publisher asked me to paint a pair of 20" × 8" (51cm × 20cm) vertical water scenes that needed to be similar but not exactly alike. I decided to paint on luan board—thin plywood that can be purchased at any lumber store. I had the lumber man cut a 20" × 16" (51cm × 15cm) piece for me, then I prepared it as described on page 10.

I then painted a scene that had two main points of interest. On the left side I placed an egret in the reeds and a sailboat in the distance. On the right side I painted a rowboat in the reeds with a sailboat in the distance. Both sides had a distant isle. When I completed the painting, I had a friend saw it in half vertically and I ended up with two paintings, each 20" × 8" (51cm × 20cm) with different subjects that had similar colors and style. The prints are called *Distant Isle l* and *Distant Isle ll*. I used the same technique for this demonstration, painting on a piece of luan board that measured 24" × 24" (61cm × 61cm) so I ended up with two paintings measuring 24" × 12" (61cm × 30cm) each. I painted a water theme similar to the *Distant Isle* paintings, but it is totally different.

1 PREPARE THE LUAN BOARD AND TRACE THE DRAWING
Prepare the board as described on page 10. Attach tracing paper to the back of the board and sketch the scene loosely but carefully. Define the boats in detail. The horizon line is 8" (20cm) from the top of the board.

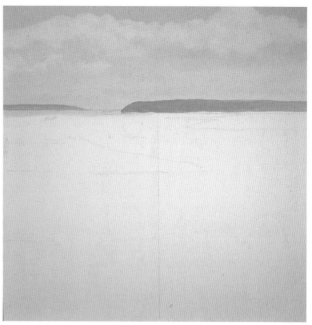

2 TRACE AND PAINT THE SKY

Transfer the basic composition onto the board with transfer paper. Trace lightly and don't include the boats and details; you just need to see where the main segments will be. The luan board is smooth and doesn't have much tooth, so it will require two coats of paint. For the sky, use a 1" (25mm) flat and paint with combinations of Cerulean and Phthalocyanine Blues, Payne's Gray, Pyrrole Orange, Yellow Ochre and Titanium White. Lighten the sky as you near the horizon by adding more white with a little orange and Yellow Ochre to make it warmer. Add white cloud formations; when dry, use the drybrush method to paint a slightly darker cloud bank under the white clouds.

3 TRACE THE DISTANT LANDMASS

Use a yardstick to steady a ½" (13mm) flat (see page 39) and paint the distant land with a mixture of a warm gray that is only slightly darker than the sky. Diffusing the value of gray pushes the land farther away. The mixture includes a little purple, blue, green and white. The land on the right side is about ¼" (6mm) farther down so it seems closer, and it is a little darker and brighter in value.

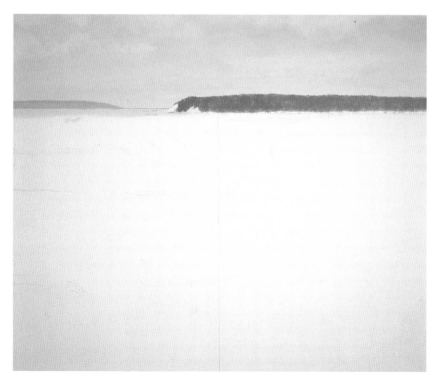

4 ADD SOME TEXTURE

When the land you just painted is dry, go back and use an old splayed-out ¼" (6mm) flat to stipple lighter and darker shades of blue-green in the tree area and add the sand banks.

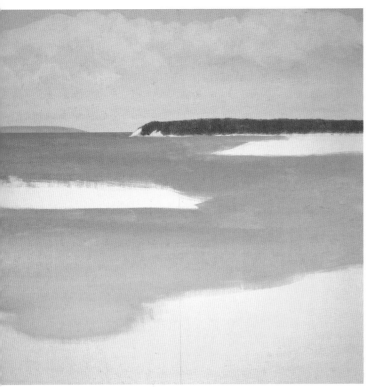

5 PAINT THE WATER

Place masking tape above the horizon line to keep the it crisp. The first coat for the water is just to cover the area. Start with a combination of Ultramarine Blue and Titanium White mixed with a little Payne's Gray for the distant water, then blend Cobalt Blue and finally Yellow Ochre, Raw Sienna and Titanium White as you near the beach. This will make a gradation of values from medium to light near the beach and will give the feeling of seeing sand under the shallow water.

6 CREATE MOVEMENT

Mask the horizon line and paint the water again with a 1" (25mm) flat down to the beach as before. To create the feeling of movement in the water, use either the edge of a flat brush or a no. 6 or larger round. [I used a 1" (25mm) flat and made the horizontal strokes freehand.] There are two values for the movement: slightly darker than the water and slightly lighter than the water. If you need more stability, rest the brush on a tilted yardstick (see page 39) and move across it with a slight amount of pressure. As you continue the stroke, add more pressure and then slowly release the pressure to decrease the size of the line. Repeat this process to make an irregular pattern beginning in the middle of the painting, making sure the yardstick or your freehand brush-strokes are level with the horizon.

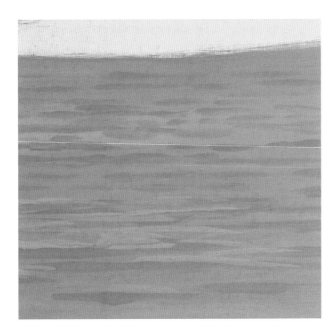

7 ADD MORE RIPPLES

The combination of dark and light brushstrokes creates the feeling of movement. Before adding any boats or detail in the foreground, go back over the water and add more ripples if needed.

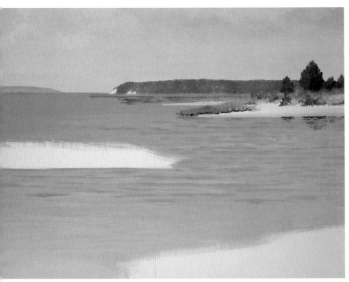

8 ADD THE TREES AND THE MARSHLAND

Paint a long, ¼" (6mm) deep, light-green marshland in front of the distant land and extend it into the water with a combination of Chromium Oxide Green, Yellow Ochre and Titanium White. Use a variety of green shades to stipple the distant trees, then create their reflections in the water with the same greens mixed with acrylic glazing liquid. When dry, use a yardstick to paint long horizontal lines through the reflections to create white-blue ripples. Paint the foliage in a variety of light greens that overlap the distant trees. Flip the brush upward to create the blades of grass. Add shadows of blue-lavender to the right of the bushes. With a no. 4 round, create reflections on the water with dark green made from Phthalocyanine Green and Raw Umber. Darken the edge of the sand so it appears to be wet.

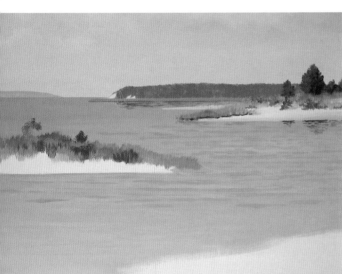

9 PAINT THE MIDGROUND LAND

Redefine and trace the midground land, the rowboat and the distant sailboat with white transfer paper. Ignore the boats for now. Paint the shrubs and grasses with a variety of greens mixed from combinations of Chromium Oxide Green, Pthalocyanine Blue, Cadmium Yellow Primrose, Yellow Ochre, Burnt Umber and Titanium White.

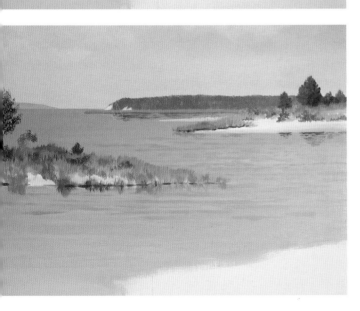

10 PAINT THE MIDGROUND TREE

Stipple the tree, letting the water in the background show through to give it a lacy feeling. Add branches and a trunk to the tree with a brownish color. Disregard the rowboat and paint right over it so you don't have to paint around it. Near the water, the upward strokes of grass need to be repeated downward into the water to create reflections. Darken the edge of the sand with warm browns.

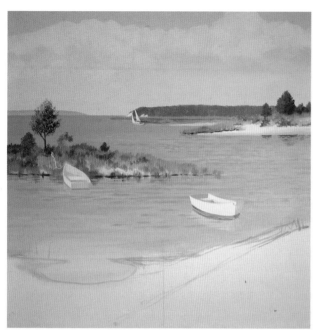

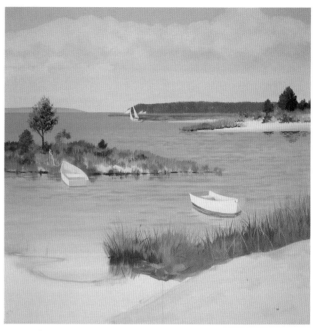

11 PAINT THE BOATS AND REFLECTIONS

Complete any areas that still need work. When dry, trace the boats using white and/or black transfer paper. The sunlight is coming from the left, so the left sides of the boats are bright white and their insides are a light blue-gray. Their reflections in the water should be slightly darker than their local color. Paint more ripples in the water with a no. 4 round and go over the reflections of the boats using a yardstick to steady the brush. Add a pole and rope that is attached to the boat on the left, and a rope attached to the boat on the right that disappears into the reed area.

12 PAINT THE BEACH AND DUNE

Block in the very light beach area on the right that slopes downward and continues accross the center onto the left side. This will take several coats of paint.

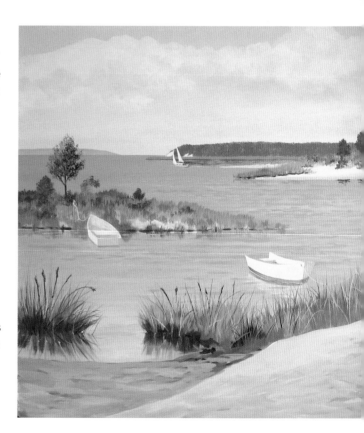

13 PAINT ALL THE GRASSY AREAS

Elongate the small pool of water to the left and paint the grasses using several combinations of Chromium Oxide Green, Burnt Sienna, Burnt Umber, Cadmium Red, Cobalt Blue, two yellows and Titanium White. Remember, what goes up must also come down when painting reflections. Paint the wet beach with combinations of purple (made from Cobalt Blue and Quinacridone Magenta), brown and white, then give the dune another coat of paint, mixing slight variations of light-tinted colors for interest.

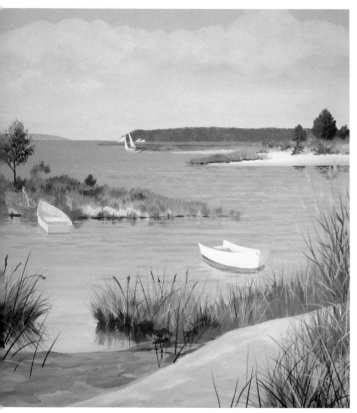 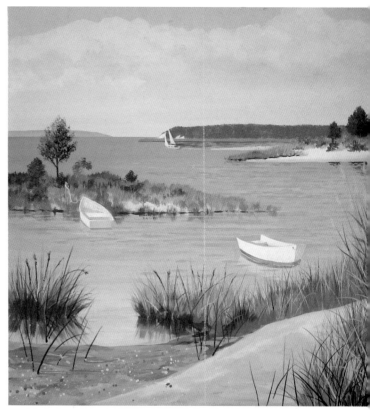

14 **ADD THE REEDS**
Reeds, also called phragmites, grow in abundance near the water and have very puffy plumes. Do a Google Image search to find plenty of good reference photos. The reeds are taller than the marsh grass and have long pointed leaves. Before you paint them, darken the sand where they will be standing for shadows. Use a no. 4 rigger to pull up long stems and add a few leaves. Paint the plumes with a mixture of Burnt Sienna, Raw Sienna and Titanium White. Vary the color of the greens frequently with at least three value changes.

15 **SPATTER AND DIVIDE**
Lay the painting flat and spatter the beach with several colors from light to dark. Also use a toothbrush for finer sprays on the left and right sides. (Refer to page 40, steps 4 and 5 for spattering techniques.) Use a rigger to create dark-blue shadows to the right of single grass blades.

Draw a line down the middle of the painting with white chalk to see the composition on each side. Wipe away any unwanted spatter with a damp paper towel.

16 ADD THE FINISHING TOUCHES

Add tiny sailboats in the distance and one in the midground on the right side (see page 58). Add a few more grasses and darken their bottoms by painting negative shapes between the blades. Glaze over the grassy area with Cadmium Yellow Primrose (see sidebar on page 22). Add some calligraphic strokes on the beach for interest (see sidbar on page 44).

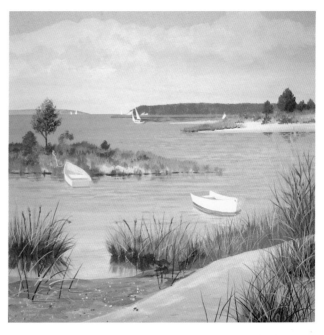

17 CUT DOWN THE MIDDLE

My friend Roy DeMeo sliced the 24" × 24" (61cm × 61cm) luan board down the middle for me. A radial saw makes a very clean cut, but the edges then have to be sanded and varnished to prevent damage from moisture. (See sidebar on page 45 for varnish mixture and application.)

"Creativity takes courage." —Henri Matisse

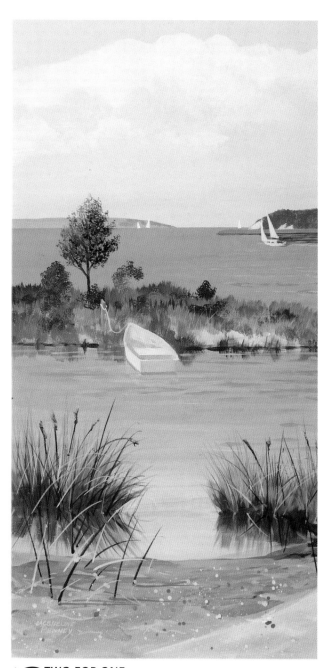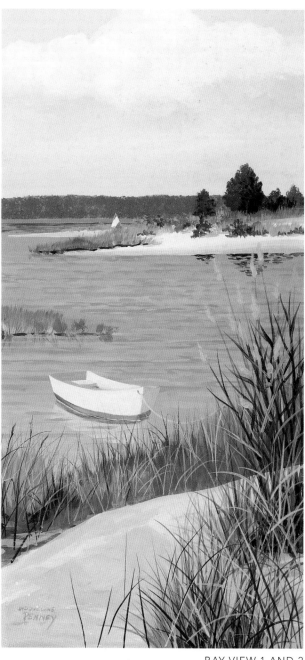

BAY VIEW 1 AND 2
24" × 12" (61cm × 30cm)
Acrylic on luan board

18 TWO FOR ONE

Sign each panel and give them both a final coat of varnish (see sidebar on page 45 for my preferred varnish method). Display the paintings in a corner on opposite walls or stagger them on one wall.

Old Fishing Shack

MATERIALS

PIGMENTS
Burnt Sienna

Cadmium Red

Cadmium Yellow

Cerulean Blue

Chromium Oxide Green

Cobalt Blue

Hansa Yellow

Mars Black,

Pyrrole Orange

Raw Sienna

Raw Umber

Titanium White

Yellow Ochre

BRUSHES
½" (13mm) flat

1" (25mm) flat

No. 2 rigger

OTHER
Acrylic glazing liquid

Masking tape

Pencil

Ruler

Tracing paper

Transfer paper (black and white)

Yardstick

A charming old shack sits just off the road on the way to Orient Point, Long Island. It is a popular subject for painters and photographers, me included. The door is closed because it isn't used anymore, so I decided to make believe that it was still in use, open the door, show a window through the door and bring a little life into it. I drew a sketch to show the dimensions of the shack and where it is placed on the canvas, measured from the center line. The rowboat comes from my photo file under *Boats* and makes a perfect prop. I thought it would be fun to have a little stovepipe chimney on the roof. Subjects do not have to be painted exactly as they are, nor do they have to have the same background.

Reference Photo: The Actual Shack

This photograph was taken in the summer, but I decided to make it fall. This view doesn't show enough water, so I created my own background. After you have drawn the shack and traced it onto the canvas, you can make the roof a little swaybacked (curved in) to add charm when you paint it.

Reference Photo: Rowboat

This rowboat tied up to one of the pilings will add more interest to the painting and further indicate activity. Feel free to scan it into your computer. Make it 3¾" (9cm) long so you can trace it. Or you can draw a slightly angled line at that length and sketch the boat within.

Helpful Measurements

I measured the placement for the shack from the center of the canvas and marked the dimensions on this drawing to help you set up your composition.

1 DRAW THE SCENE

Your tracing paper should be securely attached to the back of a 15" × 30" (38cm × 76cm) canvas and taped down at the bottom. Divide the paper into quarters and eighths if necessary. The drawing will allow you to paint large areas without interruption, such as the sky, trees, water, shack and marsh grasses. The horizon line is 5⅞" (15cm) from the top. Use transfer paper to trace the trees, horizon line and outline of the shack.

2 PAINT THE SKY

Paint the sky down to the horizon and slightly over the trees with a mixture of Cerulean Blue, Titanium White and a tiny bit of Mars Black. Add a touch of Piyrrole Orange as you near the horizon line to give it a warm glow.

3 RETRACE THE TREE LINE

Make sure the paint is dry before you bring the tracing back over to the front. Trace the grassland and the top and bottom of the tree line. Begin painting the tree area with pigment mixed with more water than usual. As a first coat, use Pyrrole Orange, Hansa Yellow and Cadmium Yellow. Paint the grassland below the tree line and up to the water's edge with a yellow-green made from Chromium Oxide Green and Cadmium Yellow.

4 PAINT THE TREES

Let the area dry, then stipple the fall trees with a splayed ½" (13mm) flat or one of your favorite old brushes. Use tinted and dark shades of orange, red, yellow and green. Many trees should overlap; don't make them go in a row like soldiers. The area below the branches, where the sun doesn't shine, should be darker. Paint a few trunks of trees with a medium tan color. The ground under the trees has colored leaves that have fallen, so don't make that area all one color. Don't worry about having to paint carefully around the shack; you'll retrace it later.

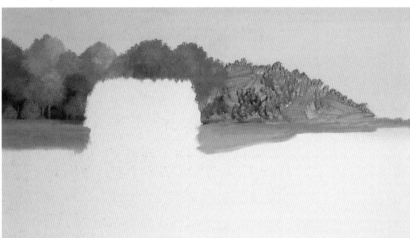

5 CONTINUE PAINTING THE TREES

Paint over the trees and grassy area down to the water's edge using thicker mixtures of the fall colors you used in steps 3 and 4. You can make more changes to the trees later if you feel they need work. Dry thoroughly and bring the tracing paper forward. Use white transfer paper to trace the outline of the shack; black transfer paper to trace the horizon line, the shore to the right, and where the water ends in the foreground.

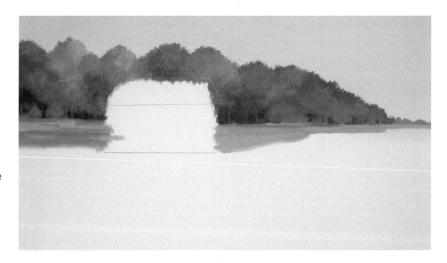

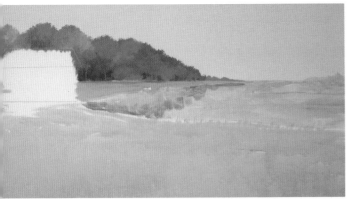

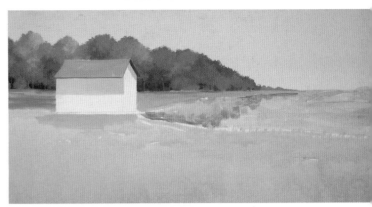

6 PAINT THE WATER

It's hard to see values and colors when there is so much white canvas. Use masking tape to keep the horizon line crisp, or rest your brush on a tilted yardstick for a smooth line. Paint the water with a thin wash of Cerulean Blue. Show where the reflections will be by adding a little of the tree color on the water. Then paint the foreground area with a 1" (25mm) flat, using several golds and greens to cover the white canvas with an underpainting.

7 PAINT THE SHACK

The right side of the shack is in more sunlight than the side facing you. Paint the shack as if it were a box standing in the light; details will be added later. Mix two basic values: one for the sunny areas and one for the shadow areas. Combine Titanium White and a little Yellow Ochre for the light value, and mix a warm blue-gray from Titanium White, Cobalt Blue and a little Burnt Sienna for the shadow value. Paint the roof with a mixture of Raw Umber, Burnt Sienna, Raw Sienna and Titanium White, making the top and left sides slightly curved. Add more Raw Sienna to the mixture and paint the underside of the roof. Paint the area below the shack with a mixture of Chromium Oxide Green and Hansa Yellow.

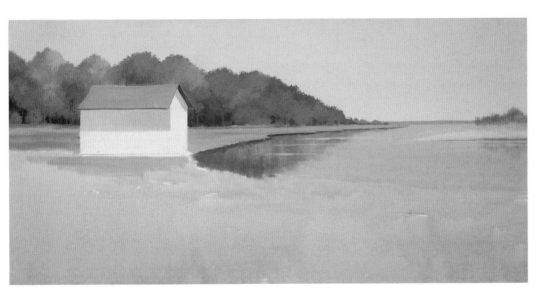

8 ADD THE WATER AND REFLECTIONS

Mix a light-blue color from Cobalt Blue, Burnt Sienna and Titanium White and paint the water with a 1" (25mm) flat. Add a little Cadmium Red and Mars Black to darken it and paint the distant land. With a ½" (13mm) flat, drybrush the reflections of the trees on the water using vertical strokes. Paint over some of the grassy area with light yellow-green on both sides of the shack. Paint the beach area on the right with Yellow Ochre and Titanium White, and stipple some greenery on top of that. Create reflections as you did on the left, then mix a light blue from Cobalt Blue, Burnt Sienna and a little more Titanium White and, using a yardstick to steady your hand, paint the ripples across the reflections. For the muddy area under the grass, use Raw Sienna and Burnt Sienna mixed with a bit of Titanium White and paint a thin line that recedes in steps.

9 PAINT THE WINDOWS

Bring the tracing paper forward and transfer the door opening, window frames and the large door facing the water that is slightly ajar. Tape all sides of the windows and paint several interesting colors within. The windows may be reflecting the grass, or perhaps you can see some shapes inside. The window that is on the other side of the building, seen through the door, will show the grass area, and the mullions will be in dark silhouette. Use the edge of a yardstick or ruler to guide your hand when painting the mullions with a no. 2 rigger.

What's Inside?

To liven up the windows and make them more interesting, paint colors within the rectangular frames. When you eventually paint the mullions, you will see how interesting the windows look with dabs of color added instead of having dark holes on a wall. I used mixtures of red, yellow and green with a little Burnt Sienna. Add either Titanium White or Mars Black to make the mixtures light or dark. The paint dabs do not have to follow the shape of the window panes; they are can be painted randomly.

10 PAINT THE DOOR INTERIORS

Paint the interiors of both doors with a rich dark mixture of Cadmium Red, Burnt Sienna, Cobalt Blue and a little Mars Black. Then cut masking tape in 1" (3cm) intervals so it can be stretched into a curvilinear shape to mold to the swaybacked roof peak and the slightly curved left roof line.

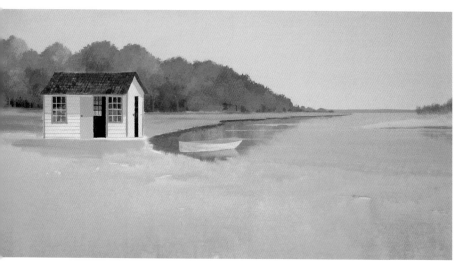

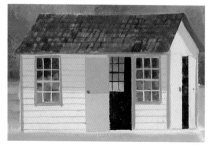

Details

11 **ADD ROOF SHINGLES AND COMPLETE THE SHACK**
The roof has several worn shingles that are shades of brown and tan. Create them with crisscrossing lines and shapes, making sure the angles are the same as the angle on the edge of the roof. Paint the door that is open partly in sun and partly in shade. Use a no. 2 rigger and rest it on a yardstick to paint across the siding with a light blue-gray made from Cobalt Blue, Burnt Sienna and Titanium White. Paint the window frames, door frame and corner trims with a darker mixture of this blue-gray (but use a lighter mixture for the sunlit half of the door). Darken a few panes of glass in the windows. Paint the boat freehand, or use tape as you did for the swaybacked roof, and drybrush the boat's reflection with a slightly darker value than the side of the boat.

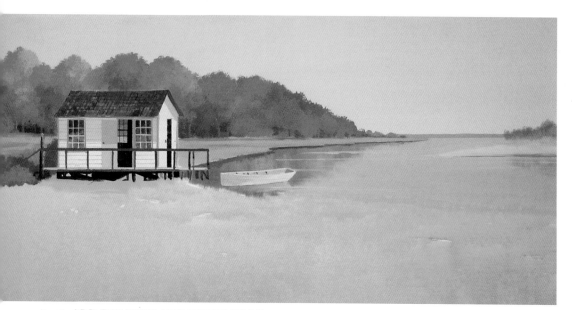

12 **ADD THE DECK AND FOUNDATION**
Paint a Cadmium Red bush to the left of the shack. The foundation allows you to see through it in several places, adding interest to an otherwise all-dark area. Paint the irregular foundation shapes in a warm dark made from purple, green, blue and red. When dry, use white and black transfer paper to trace the deck and railings. Mask the deck area and paint it a very light tan. Then mask the railings and paint them a dark gray-brown. Paint the interior of the rowboat freehand. With a no. 2 rigger, paint a ripple that goes over the boat's reflection, then add multicolored bushes in front of the stair railing.

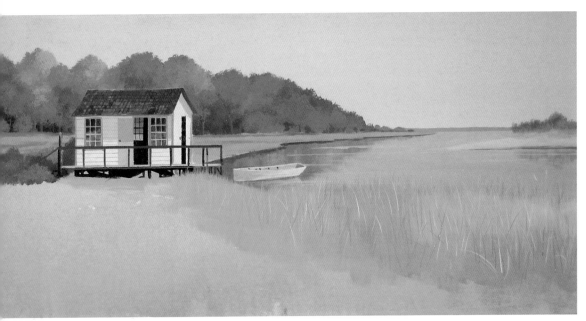

13 PAINT THE MARSH GRASSES

Create a variety of light-beige mixtures from Yellow Ochre, Hansa Yellow, Chromium Oxide Green, Burnt Sienna and Titanium White for the fall grasses. Use a 1" (25mm) flat and begin by sweeping the strokes upward. Then extend the grasses higher with a small rigger. Make some of the thin grasses with Titanium White to be glazed over with yellow and Pyrrole Orange (see sidebar on page 22). With every few strokes, change the color slightly. The grasses are close in value, but the colors do vary.

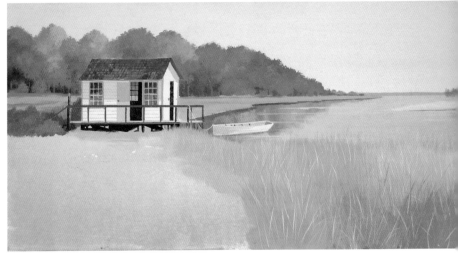

14 CONTINUE ADDING GRASSES AND GLAZE

Keep overlapping and changing colors slightly, ending with white grass strokes that will take on the color of the glaze. Each time you finish a 6" × 6" (15cm × 15cm) area, let it dry, then add a little glazing liquid over the grass in several places, using different colors such as Yellow Ochre, Hansa Yellow, Cadmium Yellow, Burnt Sienna, Pyrrole Orange and Chromium Oxide Green. If you do not like the effect, just wipe it off with a damp paper towel. You can see an unglazed area in the lower middle of the grass in my painting.

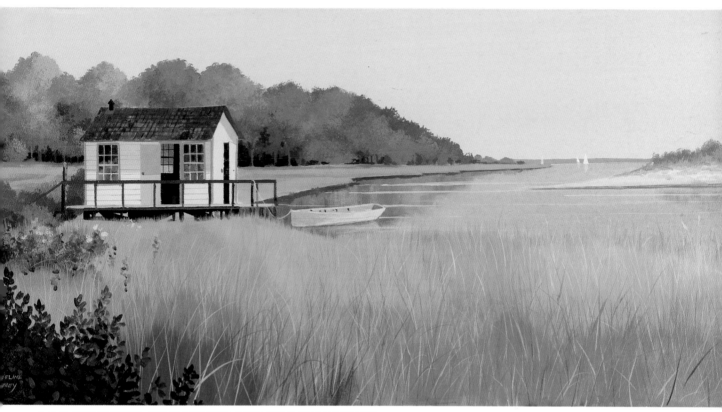

15 ADD BUSHES, WILDFLOWERS AND FINISHING TOUCHES

Add another red bush and brighten the one near the shack. Stipple small green bushes and add wildflowers such as ragweed and Queen Anne's Lace in the grass area to make it more interesting. Darken some of the trees and areas near the trunks. Place a few sailboats in the distance (see page 58). Add some red inside the door of the shack, and paint a stovepipe chimney coming out of the roof. Paint the rope tying the rowboat to the deck if you haven't done so already. Brighten the ripples in the water and add grasses to the spit of land. When the painting is dry, wash off any smudges from the transfer paper with a little detergent and water. Then add a final coat of varnish (refer to sidebar on page 45 for mixture and application).

OLD FISHING SHACK
15" × 30" (38cm × 76cm)
Acrylic on canvas

Bahamian Beach

MATERIALS

PIGMENTS

Burnt Sienna

Cadmium Red

Chromium Oxide Green

Cobalt Blue

Dioxazine Purple

Hansa Yellow

Hooker's Green

Mars Black

Phthalocyanine Green

Pyrrole Orange

Quinacridone Magenta

Raw Sienna

Raw Umber

Titanium White

Ultramarine Blue

Yellow Ochre

BRUSHES

1" (25mm) flat

No. 2 rigger

No. 4 round

OTHER

Acrylic glazing liquid

Chalk or charcoal

Gel medium

Hair dryer

Masking tape

Matte medium

Molding paste

Palette knives
(medium and large angled)

Pencil

Ruler

Bahamian beaches are very flat, making the water more transparent as it changes from a turquoise to a pink-beige in the shallows. I used a watercolor sketch I did on Harbor Island off the island of Eleuthera as my inspiration for this painting, which was done on an 18" × 24" (46cm × 61cm) canvas board using a palette knife technique. I just love to mix the luscious, colorful paint and spread it around as if I were icing a cake.

The dilapidated fence adds charm and opens a pathway to the beach. The difference between the blue of the sky and the turquoise water is significant and lets us know that the coastline is outside the United States. Two mediums can be used to extend the paint without compromising the intensity: molding paste and gel medium. Both have a consistency similar to that of cold cream. Molding paste is used throughout this demonstration each time colors are mixed. The rule of a level horizon line still applies, so measure it carefully before applying the paint.

1 DRAW THE SCENE
Sketch the horizon line, distant islands, grass, pathway and fence area onto the canvas.

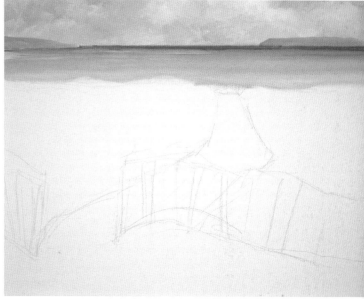

2 ESTABLISH THE COLORS

Measure and tape the horizon line. Paint very lightly to establish the colors in preparation for the palette knife. For the sky, mix pastel combinations of Cobalt Blue, Yellow Ochre, Pyrrole Orange, lavender and pink. Add the lavender-gray distant land on the right that is farthest away. To make the land on the left seem closer, drop the tape down about ⅛" (3mm) and paint it the same color.

3 PAINT THE WATER

Paint the deep water in the distance with a mixture of Cobalt Blue, Phthalocyanine Green and small amounts of Mars Black and Titanium White. It gradually becomes a light turquoise made with Phthalocyanine Green and Titanium White. As you approach the beach, add Yellow Ochre and a tiny bit of Quinacridone Magenta and Titanium White to make a very light pink-beige.

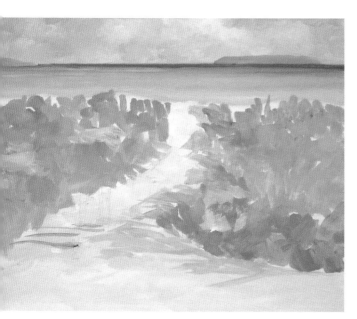

4 PAINT THE BEACH AND ADD GRASS

The beach is very light in value. Paint it with a mixture of pastel colors made by gradually lightening the blue-green water color with Titanium White and a little Yellow Ochre. The dry sand and pathway are almost pure Titanium White, mixed with very small amounts of Yellow Ochre and Cadmium Red or Quinacridone Magenta. Paint the grass with Chromium Oxide Green or Hooker's Green mixed with Titanium White; add a little Cobalt Blue for the darker green.

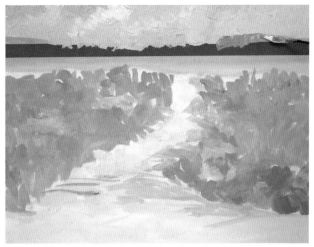

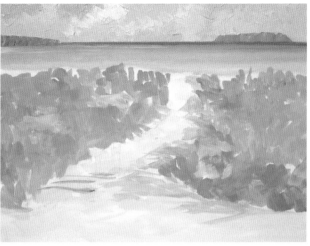

5 MIX THE COLORS WITH A PALETTE KNIFE

To paint the sky, tape across the horizon line and make sure it is level. Mix several combinations of the underpainting colors for the sky and apply them with a palette knife. The colors are made with combinations of Titanium White, Cobalt Blue, Yellow Ochre, Pyrrole Orange, pinks and purples. Add molding paste to all mixtures to extend the paint without losing intensity. Do not spread the color in just one direction; turn the palette knife as you work to give the colors movement. The more subtle colors you use, the more interesting the sky becomes.

6 PAINT THE DISTANT LAND

The distant land on the right is a medium gray-purple made from Titanium White, Cobalt Blue, Quinacridone Magenta and a little Mars Black. Remove the tape and retape it about ⅛" (3mm) lower on the left side and continue to paint the distant land. Remove the tape and allow the paint to dry or use a hair dryer to hasten the drying time.

Detail of Waves

The tiny furrows of paint applied with a palette knife create wave action.

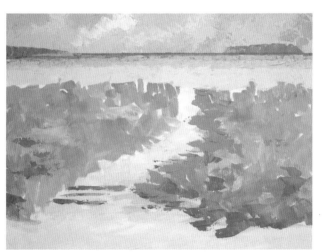

Molding Paste

Use molding paste throughout the palette knife applications. It will extend the paint and give it a little more body without diminishing the intesity of color.

7 PAINT THE WATER AND SAND

Mix a medium blue-green with Cobalt Blue, Phthalocyanine Green and Titanium White with the palette knife. Hold the knife parallel to the horizon line and bring the color down about ¼" (6mm) on the right side, and a little less on the left side where the island has been stepped down. Go all the way across the canvas with this mixture. Then make a light turquoise from Phthalocyanine Green and Titanium White. Again, hold the knife parallel to the horizon and pull the paint downward. Add a little Yellow Ochre and more Titanium White and repeat the process. The little furrows of paint will add interest to the water and look like wave action. Apply pastel colors to the sand area. Mix some of the leftover paint with Cobalt Blue and a purple mixture of Cobalt Blue and Quinacridone Magenta for some of the shadows.

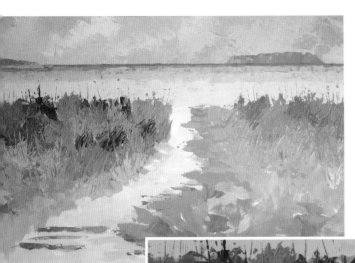

8 PAINT THE GRASSES

Make a pastel green from Phthalocyanine and Hooker's Greens mixed with several colors to paint a variety of green grasses in different values. Spread the pigment flat and then use the tip of the palette knife to score the wet paint in an upward motion, simulating blades of grass. Use the edge dipped in paint to make the skinny lines that overlap the beach area. Bring some beach shadows into the region and put greens below it, pulling some of the pigment over the shadow with the tip of the knife.

Detail of Grass

The different greens interact to add depth and volume to the patches of grass.

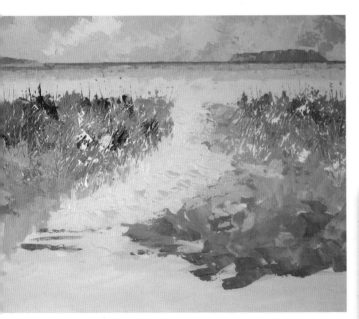

9 SCUMBLE THE PATHWAY AND GRASSES

When the grass is dry, scumble (see sidebar below) warm pastel colors on the pathway and across the ridges of the grasses in preparation for glazing. Mix Pyrrole Orange, Cadmium Red, Quinacridone Magenta and a lot of Titanium White with molding paste to create lovely pastel colors. You can also brighten areas of the grasses by scumbling over them with Hansa Yellow and Titanium White.

Scumbling

Scumbling involves dragging a fairly thick layer of color in a deliberately uneven manner over a dried layer of another color, thus creating attractive broken color effects.

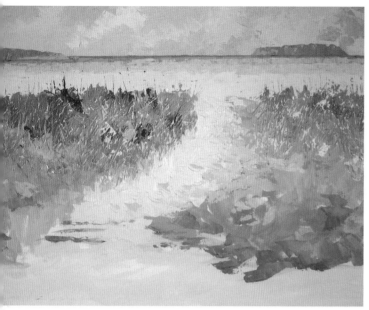

10 GLAZE THE GRASSES

Use a no. 2 rigger with Hansa Yellow and/or Yellow Ochre to glaze over the white areas on the grasses.

Of course, there are no rigid rules when it comes to creativity, so you can use acrylic glazing liquid or matte medium over existing colors with any color of your choice. Any pure color (not combined with any other color) will add a tint of color to the underpainting.

11 PAINT THE DARKER GRASSES

Continue building the grasses with a 1" (25mm) flat, making the colors darker as you near the fence area. Use leftover colors to mix new ones. The colors used for the greens are Phthalocyanine Green, Burnt Sienna, Raw Sienna, Yellow Ochre, Raw Umber and Ultramarine Blue. Mix a pale lavender for the shadow areas using Titanium White, Cobalt Blue and Quinacridone Magenta (or Dioxazine Purple and Titanium White). Add Quinacridone Magenta to make the color warmer; Cobalt Blue to make it lighter.

12 PAINT THE FENCE

Establish where the fence is by drawing it with chalk or charcoal. Use a warm gray mixed from Titanium White, Burnt Sienna and a little Mars Black to paint the slats. I recommend using a brush for the fence. Mix Cadmium Red with Titanium White and dab in the pink flowers behind the fence and near the shoreline. Add more greens around the pink flowers using Hooker's Green mixed with a little Burnt Sienna.

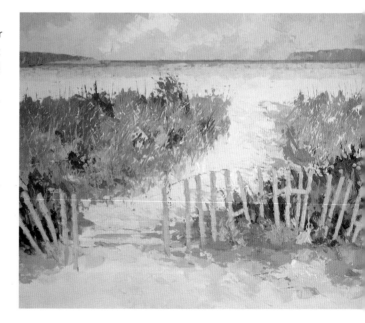

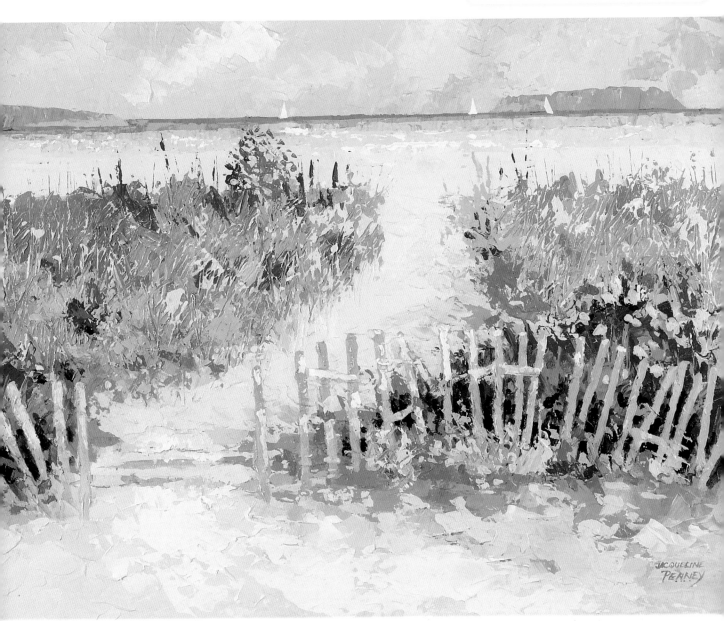

BAHAMIAN BEACH
18" × 24" (46cm × 61cm)
Acrylic on canvas

13 ADD THE FINAL TOUCHES

Be sure that areas are dry before you scumble or apply a glaze over them. Add Titanium White to some of the fences. Scumble contrasting colors over the grass areas to add interest, and scumble Titanium White over the water ridges to create wave action. Use a brush and paint some very dark areas behind the fence with Phthalocyanine Green, Burnt Sienna, Cadmium Red and any other warm dark color you choose. With the tip of a palette knife, add yellow flowers in front of the fence and to the left of the path. Use a larger palette knife to apply Titanium White in large sweeps in the foreground. Glaze over part of the fence with Burnt Sienna and Yellow Ochre. Create three tiny sailboats in the distance (see page 58). Let the canvas dry thoroughly before you give the painting a final coat of protective varnish (refer to sidebar on page 45 for mixture and application).

Lighthouse With a Red Roof

MATERIALS

PIGMENTS

Burnt Sienna

Burnt Umber

Cadmium Red

Cadmium Yellow

Cerulean Blue

Chromium Oxide Green

Cobalt Blue

Hansa Yellow

Mars Black

Payne's Gray or Neutral Tint

Pthalocyanine Green

Raw Sienna

Titanium White

Ultramarine Blue

Yellow Ochre

BRUSHES

1" (25mm) flat

1½" (38mm) flat

No. 2 rigger

No. 2 round

OTHER

Acrylic glazing liquid

Masking tape

Matte medium

Pencil

Ruler

Tracing paper

Transfer paper

Unless you are painting a dilapidated house that looks like it's falling over, you should make man-made structures stand straight; it's just as important as having a level horizon. There's only one building I know of that's cockeyed: the Leaning Tower of Pisa. For the lighthouse in this demonstration, I have drawn a diagram with measurements to help you with your composition. As in many of the previous demonstrations, all your drawing will be done on tracing paper, which will allow you to work on the sky and water without being hampered by a structure.

1 DRAW THE LIGHTHOUSE

Cut a piece of tracing paper to 24" × 28" (61cm × 71cm) so that it is 2" (5cm) taller than your 22" × 28" (56cm × 71cm) canvas. Use masking tape to secure the top of the tracing paper to the back of the canvas. To make it more secure, use staples. Divide the tracing paper into quarters by measuring 14" (36cm) across the top and bottom, and 11" (28cm) down on each side; use a ruler to draw straight, perpendicular lines connecting the marks. The lighthouse sits on the center line of the canvas, and the horizon line is ¾" (2cm) lower.

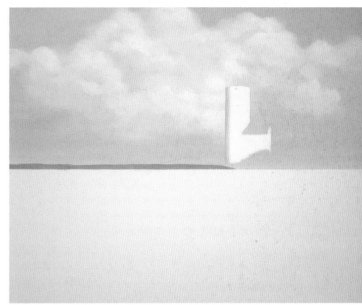

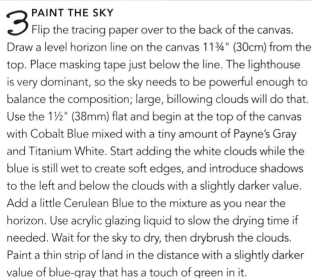

2 DRAW THE OBJECTS

Sketch the shapes of the trees, rocks, distant shoreline and beach on your tracing paper.

3 PAINT THE SKY

Flip the tracing paper over to the back of the canvas. Draw a level horizon line on the canvas 11¾" (30cm) from the top. Place masking tape just below the line. The lighthouse is very dominant, so the sky needs to be powerful enough to balance the composition; large, billowing clouds will do that. Use the 1½" (38mm) flat and begin at the top of the canvas with Cobalt Blue mixed with a tiny amount of Payne's Gray and Titanium White. Start adding the white clouds while the blue is still wet to create soft edges, and introduce shadows to the left and below the clouds with a slightly darker value. Add a little Cerulean Blue to the mixture as you near the horizon. Use acrylic glazing liquid to slow the drying time if needed. Wait for the sky to dry, then drybrush the clouds. Paint a thin strip of land in the distance with a slightly darker value of blue-gray that has a touch of green in it.

4 TRANSFER AND PAINT CRISP EDGES

Bring the tracing paper back to the front of the canvas and use transfer paper to trace the body of the lighthouse and the rocks on the canvas. Mask the sides of the lighthouse and the adjacent building with masking tape and seal with matte medium. The light is coming from the right, so the left side of the lighthouse will be in shadow while the right side is in full sun. Paint most of the lighthouse with a bright white mixed from Titanium White and a little Yellow Ochre. It will take two coats to cover over the blue sky. Mix Cobalt Blue, Payne's Gray and Titanium White and paint the shadow on the left side of the lighthouse. While still wet, smudge with your finger to blend the light and shadow colors together to create a smooth transition.

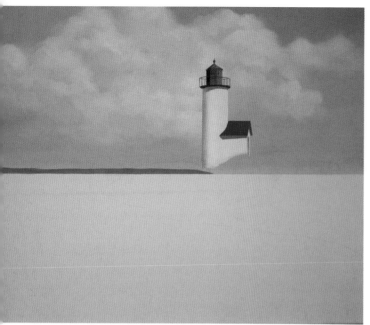

5 PAINT THE TOP, CAST SHADOW AND ROOF

Bring the tracing paper back over the canvas and trace the top of the lighthouse, its cast shadow and the roof of the adjacent building. Mix more of the shadow color from step 4, adding a little more Mars Black, and paint the crisp edge of the cast shadow; blend it with the shadow on the side. Each angle of the lighthouse top is a slightly different value: the lightest toward the sunny side, the middle a medium, and the left darker. Create the value changes from a basic gray mixture made with either Payne's Gray or Mars Black, Titanium White and a little Burnt Umber for warmth. Use masking tape to create crisp edges. Paint the railings and the very top of the lighthouse with a no. 2 round or a no. 2 rigger. The roof color is made with Cadmium Red and a little Hansa Yellow, with a bit of Mars Black to gray it down and a little Titanium White to make the value lighter. The shadows of the roof are the same color and value as the shadows on the lighthouse.

6 PAINT THE WATER

Place masking tape on the horizon line and seal it with matte medium. Use a 1½" (38mm) flat to paint the water a medium value of Ultramarine and Cobalt Blues mixed with Titanium White and Payne's Gray or Mars Black. Paint the water slightly over the rocks; don't try to paint around them as they will be re-established later. As you near the bottom, start the ripple action by using a slightly darker value and sweep across and upward near the shore on the right. Make the distant water shimmer by drybrushing a 1" (3cm) strip directly under the horizon.

Wash Away Smudges

The transfer paper will sometimes smudge the canvas when you lean on it as you are tracing, but the smudges can be washed off easily with a little soap and water on a cloth or paper towel. Any dish detergent will work. You do not have to worry about accidentally wiping away your paint, as dry acrylics are virtually impossible to remove, even with soap and water.

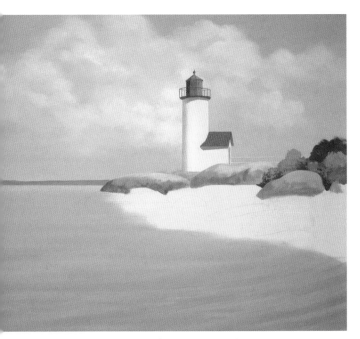

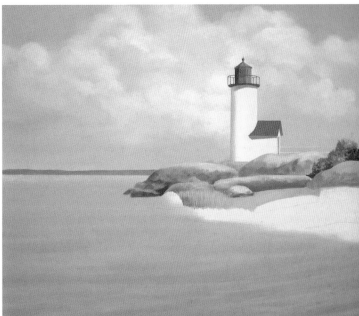

7 PAINT THE ROCKS AND SHRUBS

Bring your tracing back to the front of the canvas and transfer the rock shapes, beach area and railing leading to the lighthouse. Use masking tape to form the railing and paint it a light value of Cobalt Blue, Titanium White and a very small amount of Payne's Gray. Paint the rocks different shades of beige made with mixtures of Burnt Umber, Yellow Ochre, Burnt Sienna, Raw Sienna, Mars Black and Titanium White. Each rock should be slightly different and shaded to the left, away from the sun, and light on top. Drybrush the rocks to give them texture. Experiment with different greens for the shrubbery. Try mixing your two green pigments with Raw Sienna, Burnt Sienna and Mars Black for darks; add either Cadmium Yellow or Hansa Yellow and Titanium White for lights. Remember that all colors can be made warm or cool. Green, right out of the jar, is too intense when used alone, so it needs to be blended with other colors to make it either warm or cool, light or dark, bright or dull.

8 ADD THE TREE, SEA GRASS AND MORE ROCKS

Continue adding more rocks and light-gray sand in front of them. Paint the sea grass a light spring green (see sidebar below), adding variations of the same color. Then add white blades of grass with a no. 2 rigger. Let the grass dry, then glaze it with Yellow Ochre. Stipple the tree and shrubs with a splayed brush using a variety of greens that are warm and cool, light and dark. Use a no. 2 or 3 round for some of the leaves, dotting them in with the tip of the brush.

Mixing Beiges and Greens

See how many different beiges and greens you can make. Start with Burnt Sienna and Titanium White, which will make a warm reddish color. Dab it onto a piece of paper. Add a little Mars Black to the mixture on the brush, then blend it on the palette and place a dab of that color next to the first one. Continue mixing colors, adding Titanium White if needed to lighten.

For the greens, start with Chromium Oxide Green or even the intense Phthalocyanine Green on the palette and start mixing various colors. Make a sample color chart on a piece of paper. Continue doing this, using almost every color on the palette, and you will be amazed at how many varieties of beiges and greens you can create.

9 ADD MORE TO THE BEACH

Paint another rock and more blue-gray shadows on the beach. Drybrush the sandy area with a light beige, and add more sea grass in preparation for reflections. The grass strokes should go up as well as down. Add a small shrub next to the lighthouse, using a variation of your grass mixture.

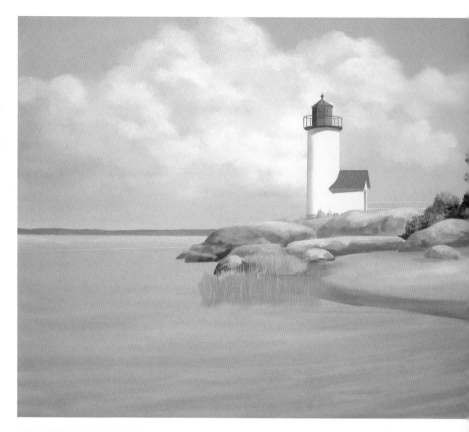

10 PAINT THE REFLECTIONS AND RIPPLES

Mix Cobalt Blue and Titanium White, and use the edge of a 1" (25mm) flat to brush through the grass reflections and create ripples in the water. Bring the tracing paper to the front of the canvas and lightly trace the lighthouse reflection. Drybrush the reflection with Titanium White, then paint over it with two values of the same blue used for the water to create more ripples. Glaze over the distant water with a little Yellow Ochre, and paint tiny sailboats in the distance using masking tape (see page 58). Blend the values on the beach so there are no hard edges and it looks like smooth sand.

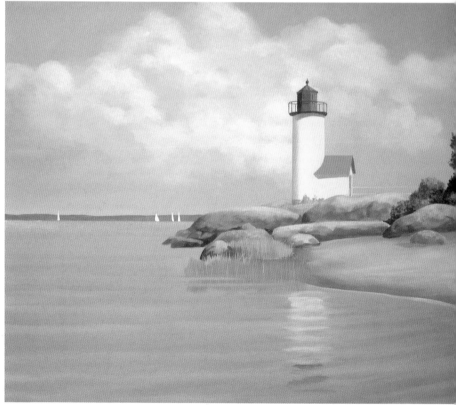

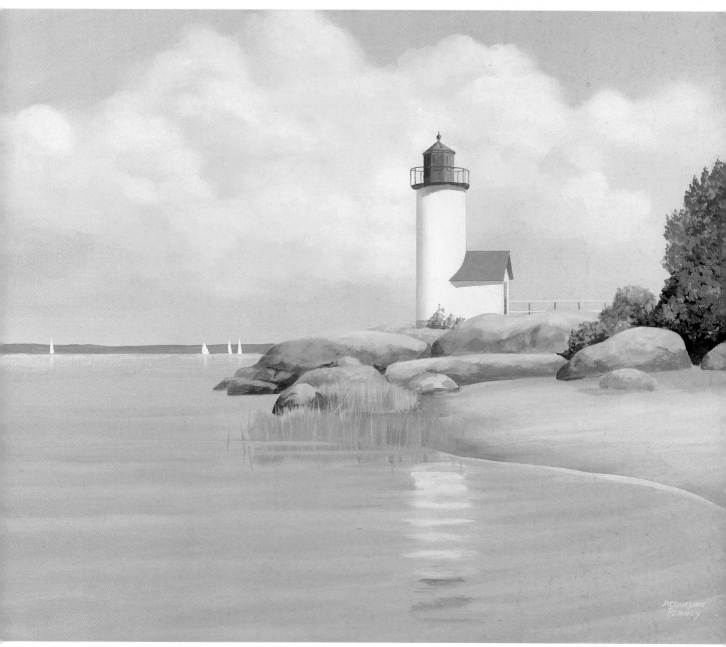

11 ADD THE FINAL DETAILS

Paint reflections under each of the sailboats, then make any necessary changes or additions to the rest of the painting. For instance, I repainted the roof to make it less red and a little lighter. The new color goes nicely with the spring green of the sea grasses. Add more greens to the tree area to make it more interesting. Use glazing to bring up some colors on the rocks—not the whole area, but rocks that could use a little more color. Good choices are Yellow Ochre and Burnt Sienna. When the painting is dry, wash any areas that became smudged with transfer paper (see sidebar on page 90), and add a coat of varnish (see sidebar on page 45).

LIGHTHOUSE WITH A RED ROOF
22" × 28" (56cm × 71cm)
Acrylic on canvas

Fisherman's Beach

MATERIALS

PIGMENTS

Burnt Sienna

Burnt Umber

Cadmium Red

Cadmium Yellow

Cerulean Blue

Chromium Oxide Green

Cobalt Blue

Hansa Yellow

Mars Black

Payne's Gray

Phthalocyanine Blue

Phthalocyanine Green

Pyrrole Orange

Raw Sienna

Titanium White

Ultramarine Blue

Yellow Ochre

BRUSHES

½" (13mm) flat

1" (25mm) flat

1½" (38mm) flat

No. 2 rigger

Nos. 0, 2 and 4 rounds

¼" (6mm) splayed flat for stippling

OTHER

Acrylic glazing liquid

Hair dryer

Head magnifier, if needed

Masking tape

Pencil

Ruler

Tracing paper

Yardstick

White chalk

Long Island is quite flat, but there are some hills that afford beautiful vistas, and the ones near the water are spectacular. Looking down on Fisherman's Beach displays a panorama that includes a bay with lots of boating activity, a safe deep-water cove for moored sailboats, the inlet that feeds into three large creeks and two beautiful beaches. It's a favorite spot for snapper fishing, clamming and crabbing.

Most of the paintings in this book are envisioned near sea level and show a flat body of water. The bird's-eye view of the scene in this painting encompasses the curve of a body of water, similar to the way it would appear from a low-flying airplane. It's a different perspective, and large things seem to be in miniature. Your eye level is still on the horizon line, way off in the distance, but you are able to see more of the water from this height. A 15" × 30" (38cm × 76cm) canvas is a good size to emphasize the horizontal expanse of the scene without having to exaggerate the sky or foreground.

1 SKETCH THE SCENE ON TRACING PAPER
Attach tracing paper securely to your canvas and sketch the basic composition on the paper. Place the horizon line 5¾" (15cm) from the top of the canvas.

2 BEGIN THE SKY

Use a 1½" (38mm) flat and create a large mixture of Cobalt Blue, a touch of Payne's Gray or Mars Black, and enough Titanium White to make a light blue for the sky. As you work downward, add Cerulean Blue, a touch of Pyrrole Orange, Hansa Yellow and more Titanium White. Continue down the canvas to the horizon line on the distant shore. Start the clouds in the upper left with a mixture of Titanium White and a little Yellow Ochre. Brush downward and at an angle to the lower right with undefined sweeping strokes. When the sky is dry, drybrush the tops of the clouds with more Titanium White mixed with a little Yellow Ochre to make them a little lighter. If you want a smoother transition, use acrylic glazing liquid.

3 PAINT THE DISTANT LAND AND TREES

At this distance the horizon line is diffused, but you should still mark it carefully. Bring the tracing paper forward and transfer the land areas to your canvas. Rest a ½" (13mm) flat on an angled yardstick (see page 39) and paint the distant land just above the horizon line with a light value of Payne's Gray mixed with Chromium Oxide Green, Cobalt Blue and Titanium White. The tree-lined land that appears closer is stepped down from the horizon line and runs straight across from one side to the other at the water's edge. For the first coat, use a ¼" (6mm) splayed flat and stipple medium values and different hues of green for the summer trees.

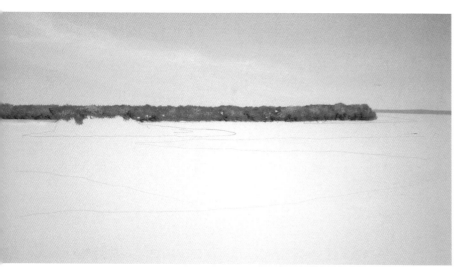

4 PAINT THE TREES AGAIN

Use the splayed brush to repaint the trees with a variety of greens mixed from Phthalocyanine Green, Chromium Oxide Green, Yellow Ochre, Burnt Sienna, Raw Sienna, Hansa Yellow, Payne's Gray, Cobalt Blue, Titanium White and Mars Black. Using a variety of hues that are not overly green but mixed with other colors to create a range of values will add depth and interest. Reserve the dark, brighter greens for the foreground area.

Add some dots of white and tan to the tree area with a no. 0 round so that there appear to be houses behind the trees. There is not much happening in front of the tree area, so you can go back any time to make adjustments if necessary.

 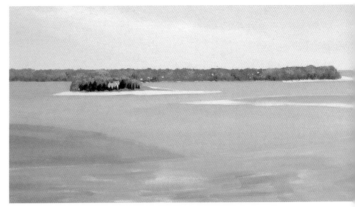

5 BLOCK IN THE WATER AND FOREGROUND AREA

Measure down from the top of the canvas and make sure the land near the water is perfectly level under the tree area. This is a good time to block in the water and foreground land to help establish overall colors and values. Paint the water with a mixture of Ultramarine Blue, Payne's Gray, a tiny bit of Chromium Oxide Green and Titanium White. Make it a little brighter near the foreground by adding a little Cerulean Blue, a tiny bit of Phthalocyanine Blue and Titanium White as you come forward. Don't worry about painting the water over beach areas; they can be retraced later. Use a variety of greens to underpaint the foreground beach.

6 ADD HOUSES, TREES AND MORE WATER

There are two houses that can be seen from this angle, nestled in pine trees on the spit of land. Use Cadmium Red mixed with Titanium White and a little Payne's Gray or Mars Black to make a pastel pink color for the first house. Paint the roof with a very light mixture of Payne's Gray and Titanium White. The second house can barely be seen and can be painted with a little darker gray than the roof color. The same greens used in the background should be a little darker and more intense as they near the foreground. Add Cadmium Yellow to Chromium Oxide Green to make it a yellow-green, and a little Mars Black to make a darker green. Give the water a second coat of paint with the same mixture from step 5. The colors become more intense in the midground.

7 ADD THE MARSH GRASS AND TREE REFLECTIONS

Retrace the beach areas. Use a no. 2 rigger to paint the most distant shoreline with a mixture of Titanium White and a little Yellow Ochre in a very thin line. With a ½" (13mm) flat, paint the beach area near the point of land with the same color and lightly drag it out into the water to create a sandbar. All the white beach areas will need at least two coats of paint. With the edge of a ½" (13mm) flat, paint the grassy marsh area between the trees and water, holding the brush on a slanted yardstick to steady it (see page 39). Bring some of that color up into the treeline to show a sloping lawn that goes down to the marsh grass. This will also need two coats of paint. Use a no. 4 round to drybrush the tree reflections on the water in the distant cove. Make sure there is no hard edge. This contrast will make the tiny moored sailboats stand out when you add them later.

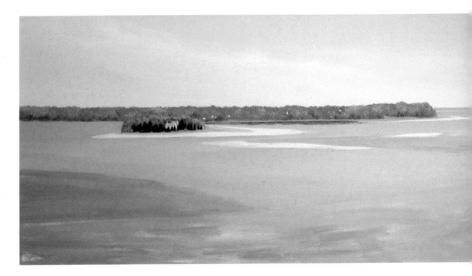

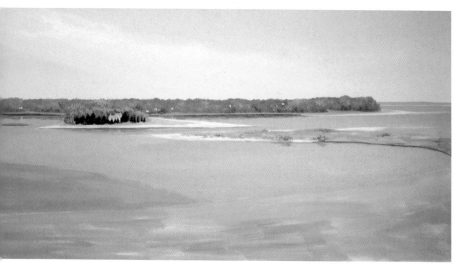

8 ADD MORE REFLECTIONS AND MARSHLANDS

Paint more tree reflections and marsh-lands on the left side of the cove. Add grass in front of the trees on that side, and paint a tiny house tucked into the trees with a very light reflection of it on the water.

Paint reflections in the inlet, and repaint the beach areas with Titanium White and a little Yellow Ochre. Add more greens to the beach, and paint bushes in the beach grass with light to medium values of mixed greens.

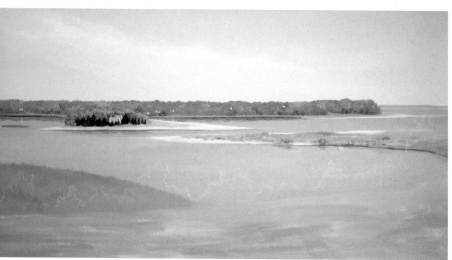

9 PAINT THE DOCK AND DRAW BUSHES WITH CHALK

Trace the tiny dock and paint the walkway with a very light beige. Use a no. 2 round to paint the pilings and the tiny rowboat. As you paint the sides of the boat with Titanium White, smudge a little of the paint downward with your finger to create a tiny reflection.

Paint the marshland below the hill in the foreground, and with just a little flip of a 1" (25mm) flat, bring a tiny bit of the mixed green color into the water to simulate blades of grass. At this distance they will not be tall blades of grass but just a hint. Mix several greens and paint with tiny upward strokes all over the marshland. When the area is dry, draw bushes on the hill with white chalk, making sure they are not all the same size and shape.

Practice Mixing

One way to learn how to mix paints is to try duplicating the colors you see in a glossy magazine. Paint the colors right next to the pictures on the magazine pages to see how your mixtures compare. Keep in mind that all color printing is made from these four colors: cyan (blue), magenta (red), yellow and black, and remember that acrylic paint dries a little darker than when wet.

A good challenge is to make a variety of beiges and "in between" colors. Start by determining the root color. Is it kind of yellow, orange, red, purple, blue or green? Then decide if it needs to be brighter or darker. Add the color's opposite to make it brighter. For example, if the color is too red, add green to the mixture. You can also add white to make it lighter, or black to make it darker.

10 PAINT THE BUSHES

The first application of the leaves and bushes are medium-dark in value. Use a variety of greens made with Chromium Oxide Green, Burnt Sienna, Burnt Umber, Raw Sienna, Yellow Ochre, Ultramarine and Phthalocyanine Blues, Hansa Yellow and Cadmium Red. Use a no. 2 round to paint the pointed oblong leaves over the water area, allowing the background color to show through the top leaves. As you near the hillside, pull the color downward so there is not a straight line going across. Use a no. 0 round to overlap the bushes and create a feeling of depth.

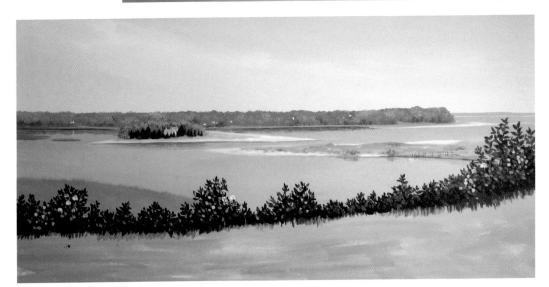

11 ADD MORE LEAVES AND FLOWERS

Begin on the right side of the hill where the paint is dry and paint darker and lighter leaves over the underpainting. Make a rich dark color with Phthalocyanine Green and Burnt Umber; add a little Titanium White to make it a lighter green. Some of the leaves can be made with pure Chromium Oxide Green, but most should be mixtures of green.

Continue the bushes across the hill, then begin adding Queen Anne's Lace on the right side with a splayed brush and Titanium White paint. Decide where the cornflower blossoms will go and paint them with Titanium White. When dry, go over them with a light blue made from Cobalt Blue and Titanium White; make some of them darker by using Ultramarine Blue and Titanium White. Paint their leaves a lighter, brighter yellow-green to stand out from the leaves of the bushes. The dark bushes will be a nice backdrop for the lighter grasses, and the cornflowers echo the blue of the water, just as the Queen Anne's Lace will echo the white of the distant sailboats. All of these contrasts add interest to the scene.

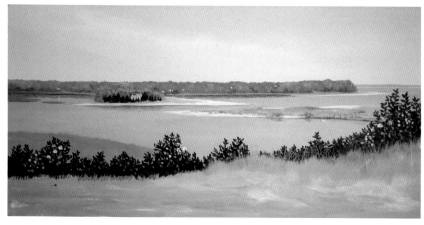

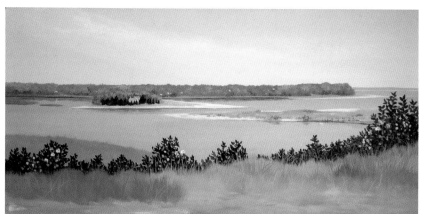

12 **ADD GRASS TO THE HILLSIDE**
There is an empty lot on the top of the hill with wild grasses growing in the sandy soil. Paint this as if you were painting grasses in the dunes, leaving some of the flat sandy soil exposed to create a walkway of sorts. Make light mixtures of beige-green with Titanium White, Yellow Ochre, Raw Sienna, Burnt Umber and Chromium Oxide Green. Use a 1" (25mm) flat to brush the color upward into the bushes and create tiny blades of grass. Load a no. 2 rigger with the same mixture and pull the grasses up over the bushes and even over the water in places. Then use Titanium White and Yellow Ochre for very light blades of grass over the entire area.

13 **CONTINUE PAINTING THE GRASS AND PATHWAY**
Continue the grass across the hillside, mixing slightly different beige-greens after every few strokes. Add very light blades of grass with Yellow Ochre and Titanium White throughout. Paint the pathway or clearing with mixtures of Burnt Sienna, Raw Sienna, Yellow Ochre, Ultramarine Blue, purple and Titanium White in subtle hues and light values with a 1" (25mm) flat. Near the grass, extend the blades upward with the pathway color and elongate them with a no. 2 rigger. This creates a subtle transition from the sandy ground to the grass. Use a hair dryer to hasten the drying time when painting the grass so that each new application is crisp, and give second coats of paint where needed.

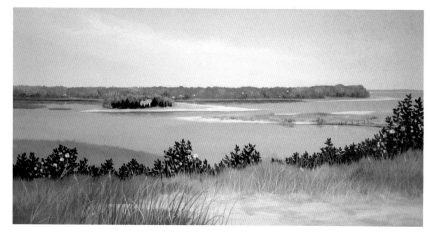

14 **COMPLETE THE GRASSY HILL**
Make the path lighter and extend it over to the left a bit. Paint grass over that side with a medium green mixture. When dry, use acrylic glazing liquid mixed with Yellow Ochre and Hansa Yellow and apply a few glazes where the very light grass will pick up the yellow tint to add color interest. Use blue-purple and yellow-pink glazes on the pathway.

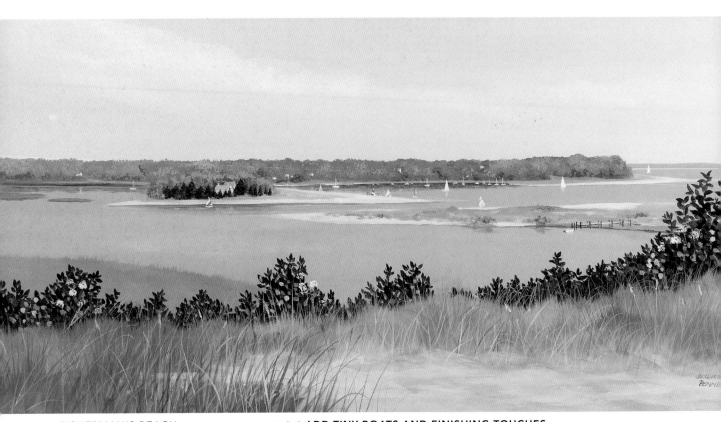

FISHERMAN'S BEACH
15" × 30" (38cm × 76cm)
Acrylic on canvas

15 ADD TINY BOATS AND FINISHING TOUCHES
With masking tape and a no. 0 round, paint the white sailboats in the distant cove, making sure the masts are straight up and not tilted (see page 58, step 12). Paint a few sailboats in motion as well as the small Sunfish boats near the shore and in the inlet. Smudge some of the white paint in the water to create reflections. Paint the Sunfish sails white first, then add stripes and color on a few when dry. Enlarge the rowboat at the end of the dock slightly, and darken the pilings. Glaze over foreground grasses with Burnt Sienna and Chromium Oxide Green. Drybrush a little more Titanium White on the clouds and add some Titanium White to the water for their reflections.

"The artist's world is limitless. It can be found anywhere, far from where he lives or a few feet away. It is always on his doorstep."

—*Paul Strand*

Maine Lobster Boat

MATERIALS

PIGMENTS
Burnt Sienna

Burnt Umber

Cadmium Red

Chromium Oxide Green

Cobalt Blue

Mars Black

Payne's Gray

Phthalocyanine Green

Quinacrodone Magenta

Raw Sienna

Raw Umber

Titanium White

Ultramarine Blue

Yellow Ochre

BRUSHES
½" (13mm) flat

1" (25mm) flat

1½" (38mm) flat

No. 2 rigger

Nos. 2 and 4 rounds

OTHER
1½" (38mm) palette knife

Acrylic glazing liquid

Hair dryer

Pencil

Ruler

Tracing paper

Transfer paper

Yardstick

Maine is a special place. It has its own smells that imprint on one's senses. The contours of rocks that line the coast give off warmth on sunny days and, a feeling of solidity on cold, foggy days. Many times the fog that rolls in diffuses shapes, giving softness to the austere landscape, and sometimes the sun squeezes through like a spotlight illuminating a small area, creating beautiful colors and reflections. Having spent many wonderful days on a small island in Maine, I feel connected to not only the landscape but to the moods of the weather, the tastes of wild blueberries, mussels and, of course, lobster.

During one of my trips to Maine, I watched a lobsterman moor his boat in a small cove at high tide, and a few hours later he returned to work on the bottom of the boat that was exposed at low tide. I thought the scenario would work well for a painting of a lobster boat rolling about in turbulent water. A 12" × 24" (30cm × 61cm) canvas is ideal for a seascape as it accentuates the horizontal water.

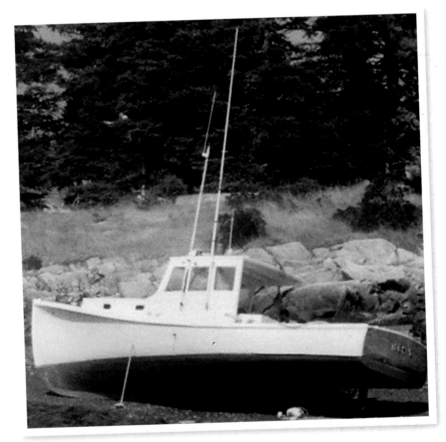

Reference Photo

I scanned the photo and cropped around the boat in Adobe Photoshop, then printed it out with the length approximately 2¼" (6cm), about the size it will be on the painting.

1 SKETCH THE SCENE
Draw a level horizon line 3" (8cm) down from the top of the canvas. Trace the boat and sketch the waves and rock area on tracing paper.

2 PAINT THE SKY
With a 1½" (38mm) flat, begin the sky using Cobalt Blue, Payne's Gray and Titanium White. While the paint is still wet, add the suggestion of clouds with Titanium White.

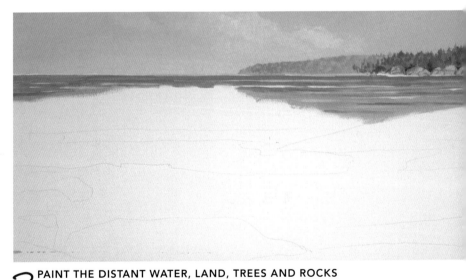

3 PAINT THE DISTANT WATER, LAND, TREES AND ROCKS
Redefine the horizon line with pencil. Mix Ultramarine Blue, Payne's Gray and Titanium White to paint the water with a 1" (25mm) flat, resting the brush on a tilted yardstick for a level horizon. Paint down to the rock area and large wave. Add the distant land above the horizon line with dabs of muted colors, and brush in pale Yellow Ochre near the water's edge to simulate distant rocks.

Then add the spruce trees and the large rocks that are a bit closer to the foreground. Use a no. 2 or 4 round for the trees and paint them with several mixtures of Chromium Oxide Green, Ultramarine Blue, Burnt Sienna, Raw Sienna, a little Payne's Gray and Titanium White. Make the rocks with similar mixtures, but mostly Yellow Ochre. Add small white waves with a no. 2 round or no. 2 rigger on the horizon line and in the midground water near the large rocks. Mix a blue that is slightly darker than the water to create some darker waves.

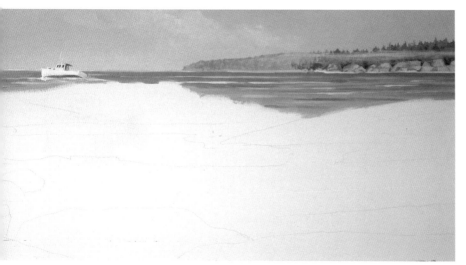

4 CREATE FOG AND PAINT THE BOAT

When the land area is dry, mix Titanium White with a little water or acrylic glazing liquid and lightly brush over the trees to create misty low-lying fog. Before you trace the boat with transfer paper, make sure your background is completed to your liking.

Trace the boat and use a no. 2 round to paint it with Titanium White several times to cover over the blue. Mix Burnt Sienna with a little Cadmium Red, Mars Black and Titanium White for the exposed underside of the boat. Paint the windows and underneath the roof with a medium-dark gray. Add splashes of waves in front of the boat and along its underside.

Mix Titanium White with a little water and dip the edge of a palette knife into it. Slide the edge over the top of the boat to create antennas; wipe away any extra paint to create a very thin line.

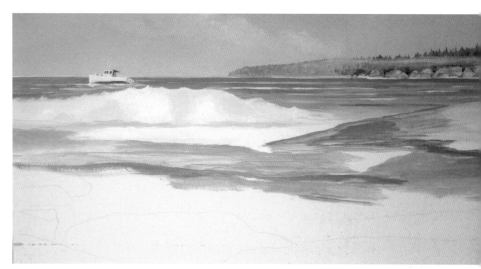

5 BLOCK IN THE LARGE WAVE AND MIDGROUND ROCKS

Paint the rocks with earth colors: Yellow Ochre, Raw Sienna, Raw Umber, Burnt Umber and Burnt Sienna; use Titanium White or Mars Black to lighten or darken as needed. The large wave is predominantly white with touches of aqua made from Phthalocyanine Green and Titanium White. You will need to paint several coats of white, especially at the top of the wave where it meets the distant water.

Warm and Cool Colors

Paint supply stores have displays of paint chips in just about every color from white to black. If you look at the white chips, you will see a large variety of mixtures that are considered "white." They are tinted with other colors but remain in the white category because no one color is predominant in the mixture. If you look carefully, you will be able to determine the difference between a warm and a cool white. All the colors in the display can be created with the colors on your palette. Rocks don't come in one shade or value: they can be light, medium or dark; they can be warm or cool.

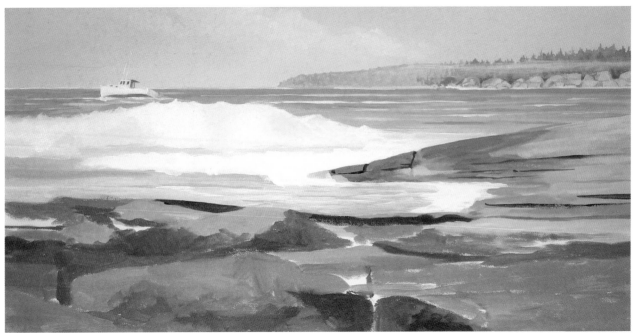

6 PAINT THE LARGE FOREGROUND ROCKS

You'll need several thick coats of paint to create the foreground rocks and water. Use a ½" (13mm) flat and mix the same colors you used for the midground rocks to create good contrast between light and dark. Use a no. 2 round or a no. 2 rigger to paint the dark striations on the midground rocks, and mix deep blues and purples for the water between the foreground rocks.

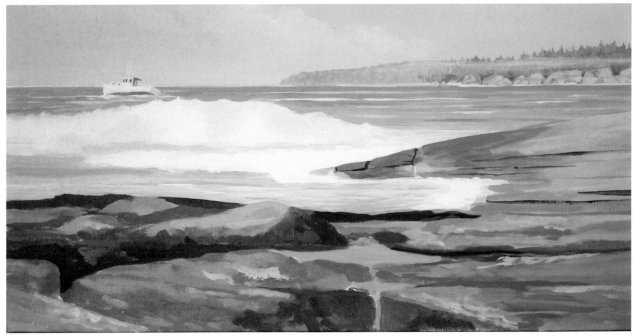

7 MAKE THE ROCKS LOOK WET

Create wet, slippery areas that are almost black on the rocks, and continue adding shadows and highlights until you are satisfied. Create the dark purple with Ultramarine Blue and Quinacridone Magenta, and introduce other reds to add warmth.

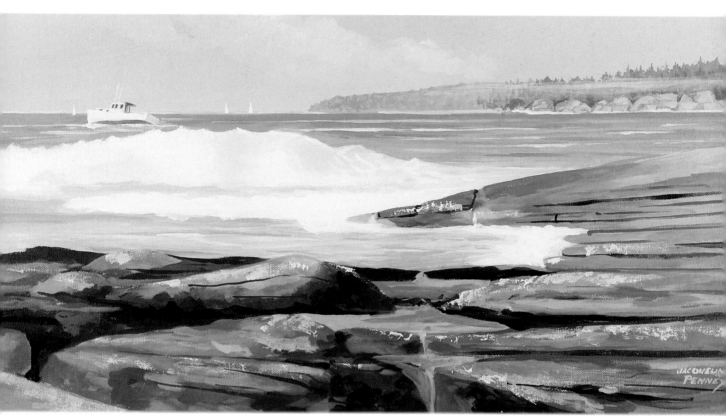

MAINE LOBSTER BOAT
12" × 24" (30cm × 61cm)
Acrylic on canvas

8 ADD SHIMMER, CRACKS AND DISTANT BOATS

When you are finished painting the rocks, use a flat brush or a palette knife to scumble over a few of them with Titanium White to create a shimmering effect. Then paint several cracks or striations on the rocks with a no. 2 round or no. 2 rigger, steadying the brush on a yardstick if needed. Use a dark mixture of Phthalocyanine Green and Burnt Sienna for the cracks.

After scumbling more Titanium White over the rocks, dry the area and then glaze over it with Yellow Ochre. Add some very light red in a few places to give them more color. Use masking tape and several coats of Titanium White to create tiny sailboats in the distance (see page 58, step 12).

The rocks shimmer in the spotlight of sun that breaks through the clouds. The sharp contrast between the white water and the huge water-splashed rocks adds excitement to the scene. The dripping water from the small pools between the rocks adds a nice vertical to an otherwise horizontal motif.

"The world of reality has its limits; the world of imagination is boundless."

—*Jean-Jacques Rousseau*

August Moon

MATERIALS

PIGMENTS

Burnt Sienna

Burnt Umber

Cadmium Red

Chromium Oxide Green

Cobalt Blue

Hansa Yellow

Mars Black

Payne's Gray

Pthalocyanine Blue

Quinacridone Magenta

Raw Sienna

Titanium White

Yellow Ochre

BRUSHES

½" (13mm) flat

1" (25mm) flat

1½" (38mm) flat

Nos. 4 and 6 riggers

Nos. 2, 4 and 6 rounds

OTHER

Acrylic glazing liquid

Compass or small pill bottle

Masking tape

Paper towels

Pencil and eraser

Ruler or yardstick

Toothbrush

Tracing paper

Transfer paper (white and black)

T-square

White chalk or pencil

Long Island runs west to east. Sometimes, when heading east on the Long Island Expressway, you can look in your rearview mirror and see the sun setting, while straight in front of you the huge moon is rising. Everything in front of the moon is backlit, or in silhouette. It's a magical time that creates a magical feeling!

The dark, backlit landscape in this painting casts shadows and is reflected onto the water. All the lights in the scene are also reflected on the water, and the contrast of light and dark brings the painting alive. The moon's glow sheds its brilliant light on the beach and grasses, making the foreground quite light.

1 SKETCH THE SCENE
Firmly attach tracing paper to your canvas and sketch the composition of the scene. Use black transfer paper to trace the horizon line and water area below onto the canvas.

Houses

Although the houses are dark, their shapes need to be accurate. Look through the real estate section of a newspaper or go to a real estate office and ask for one of their brochures that shows houses for sale. This will give you a variety of houses from which to choose. Draw them to scale on tracing paper. It is important to make them perfectly straight and level—not tilted. When they are painted, the value correction will push them back into the dark trees and allow the lights in the windows to shine.

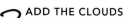

2 PAINT THE SKY

Use a 1½" (38mm) flat and mix a medium value with Cobalt Blue, Titanium White and a little Mars Black. Test the color on a piece of paper and dry it to make sure you have the color and value needed for the sky. Paint the sky with horizontal strokes, adding a little Burnt Sienna to the mixture as you near the horizon to add some warmth. Paint the water area with the same mixture, but add a little more Titanium White and Cobalt Blue to make it just a little lighter and bluer than the sky. Let the paint dry thoroughly.

3 ADD THE CLOUDS

With a 1" flat, mix acrylic glazing liquid with just a little Titanium White and paint the clouds. Use a circular motion to brush in the top of the clouds. Then add a little clean water below the puffs of clouds and use your finger to smudge and blend the white mixture into the clear water to create a gentle transition, leaving no edge at all on the bottom of the clouds. You can do this with a brush, but it's just as simple to use your finger. Repeat this process if the first coat is not white enough.

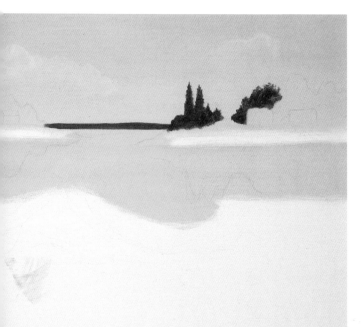

4 ADD THE DISTANT LAND AND TREES

Bring the tracing back to the front of the canvas and use black transfer paper to trace the distant shore and horizon line, as well as the trees, the sides of the houses and slight reflections on the water.

Mix Cobalt Blue, Burnt Sienna and a little Mars Black to make a fairly dark value for the distant land. Use a tilted ruler to steady a flat or round brush of your choice. The horizon line must be perfectly level, but the tree line can be uneven.

Add a tiny bit of Hansa Yellow to your mixture, but keep the value quite dark, and paint the large trees with a no. 4 round. Create the jagged edges of the leaves by dotting in tiny shapes with just the very tip of the brush. Leave a little space between the houses so you can paint a small backlit tree in the next step. You can paint right over the houses because they will be re-established later.

5 ADD MORE TREES

Before you paint the dark areas of the trees, add a tree trunk with about three branches between the two houses on the right. You may need to paint the trees with two coats to cover over the blue sky, but don't make them too dark. Allow some of the sky to peek through; this will add depth and interest. Continue adding dark trees on the left. Try mixing Phthalocyanine Blue instead of Cobalt Blue with Burnt Sienna for some of the darkest areas.

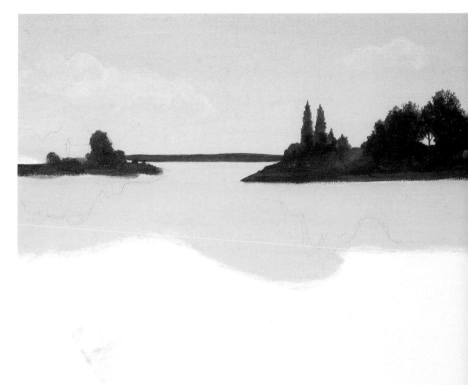

6 STIPPLE AND TRACE

Finish painting the trees and let them dry. Then mix another dark value with Phthalocyanine Blue, Burnt Sienna and a little Quinacridone Magenta and stipple over the underpainting with a no. 4 or 6 round. Allow small areas of the underpainting to show through for interest. Paint the small meadow area with a little Cobalt Blue and Titanium White mixed with some of the dark that was used for the trees. Drybrush it over the area lightly. After everything dries, use white transfer paper to trace the houses among the trees. Just trace the shapes of the house, not all the windows. You will add those in the next step.

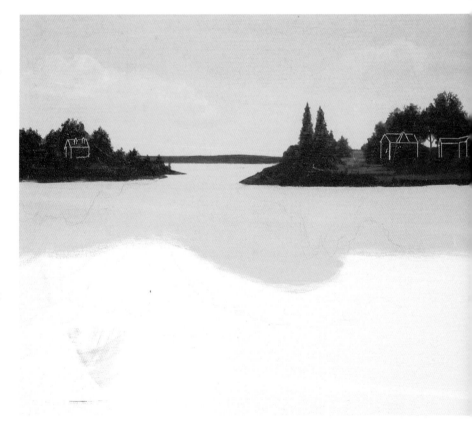

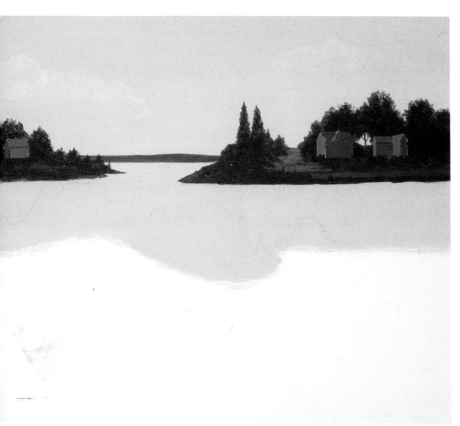

7 PAINT THE HOUSES

Use small strips of masking tape to mask and paint the side of the house that is facing you. Blend a mixture of Phthalocyanine Blue, Burnt Umber, Mars Black and a tiny bit of Titanium White to create a warm dark color. Use this same mixture, possibly with slight variations, to paint the other houses that face away from the light of the moon. After those dry, use the masking technique to paint the sides of the buildings that are lit by the moon. Paint the roof the same way; because it gets more of the moonlight, make the color a little lighter and bluer. You can still see the white lines that define the houses; wash them away with a damp towel.

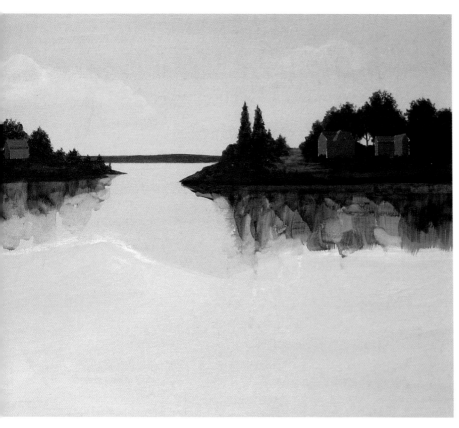

8 TAKE AWAY THE WHITE AND BEGIN TO GLAZE

It will be easier to see values if you paint over the white canvas in the foreground beach area. Use a 1½" (38mm) flat to paint mixtures of Yellow Ochre, Raw Sienna, Cobalt Blue and Titanium White for the underpainting.

Mix acrylic glazing liquid with several different medium-dark colors to create an underpainting for the reflections on the water. Don't brush the colors in— just lay paint them loosely. Continue mixing interesting darks blended with the glazing liquid, using blues, greens, earth colors and a little Mars Black. Don't make the reflection just one flat color; overlap different values and let some of the distinct colors show. Wash away any hard edges with a little water on your brush. If it drips down, just wipe it away with a paper towel.

9 DARKEN THE SKY AND THE WATER

The sky needs to be a little darker, as does the water below. Mix Cobalt Blue with acrylic glazing liquid and brush in one direction across the top of the canvas. Add more glazing liquid to lighten the color, and brush across again. Continue downward until the mixture becomes clear. Use a paper towel to pick up any tint that may have covered the clouds. Repeat the same process in reverse, starting with the water near the beach and working upward.

Paint with more combinations of the colors you've already used, but make them more opaque and let some of the underpainting show through.

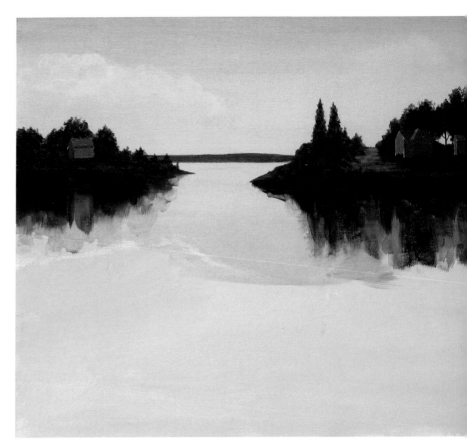

10 ADD THE MOON

Use a compass or a small pill bottle top to draw the moon. Place it so it will reflect on the water just above the spit of land on the right and down to the curve of water by the beach. Mix Titanium White with a little Hansa Yellow, Cadmium Red and Yellow Ochre to paint the moon. Use a no. 4 or 6 round and be very careful to stay within the lines.

The reflection of the moon will not be hard-edged. It will have ripples going through it, and the warm light color will be elongated on either side of the reflection. However, the reflection itself must be perfectly straight up and down, not at an angle. Use a T-square or ruler to draw straight lines down from each side of the moon with a sharpened piece of white chalk. These lines will guide you when you paint the moon's reflection.

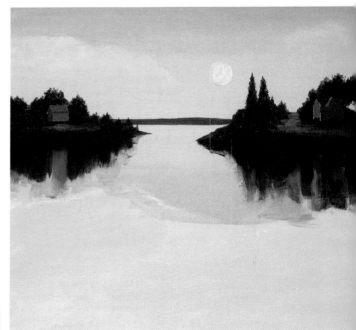

Painting Round Objects

When painting something round, it helps to turn your canvas after several strokes because your hand can't twist around and keep the tip of the brush on the line.

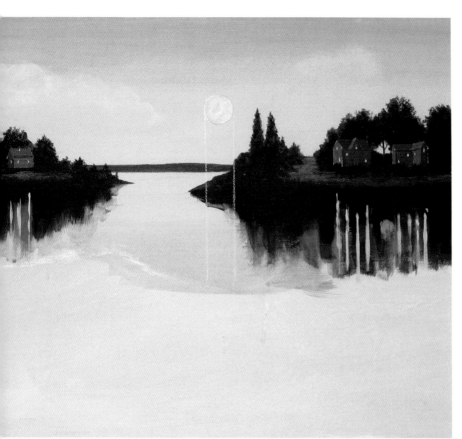

11 TURN THE LIGHTS ON
Use a white pencil or piece of sharpened chalk to draw staggered windows on the houses. Mix Hansa Yellow with a tiny bit of Cadmium Red and a little Titanium White and dot in the windows that have lights on with a no. 2 round. Use a T-square or ruler to guide the same color downward for the reflections on the water. Paint the tiny chimneys with a mixture of Burnt Sienna, Mars Black and just enough Titanium White to make them visible upon close inspection. You do not want them to stand out at first glance.

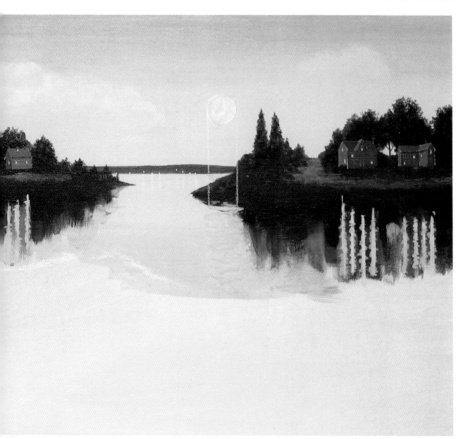

12 ZIGZAG THE MOONLIGHT
Use a no. 6 round to paint the moon's reflections with the same color you used for the reflections from the window lights. Create large zigzag strokes, going just a little beyond the chalk guidelines. This may take two coats. Go over the window light reflections with smaller zigzags.

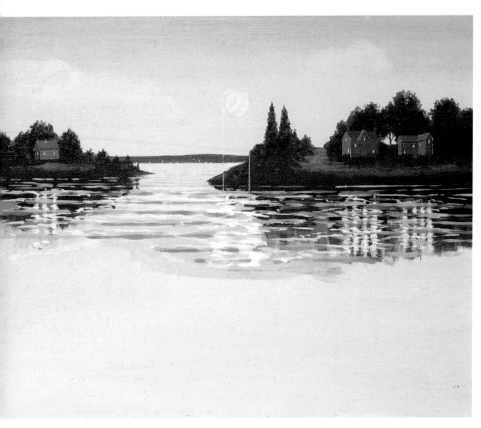

13 CREATE RIPPLES

Mix a blue that is slightly darker than the water. Use a tilted yardstick level with the horizon line and glide a no. 2, 4 or 6 round across the water to create ripples. Don't paint in one continuous motion; use varying lengths and widths. This can be accomplished by using just the tip of the brush and pushing down on it to create thick lines, then releasing the pressure altogether to create a gaps in between. Make a darker blue from your existing mixture, and paint it across the water in the same way.

Use Titanium White on the tip of your brush to make little zigzag lines over the entire water area. This creates highlights and prepares the way for glazing. Three values from dark to light have been used. This process takes time. Allow yourself the time to see it develop without instigating negative thoughts.

14 GLAZE THE WATER

Glaze over the water nearest the houses with a little Burnt Sienna mixed with acrylic glazing liquid. Bring some of it downward over part of the yellow reflections. Do this on both sides.

Glaze over much of the water again with Phthalocyanine Blue. When dry, use a 1" (25mm) flat to drybrush pure Titanium White over all the water with smooth, even strokes. This helps flatten the water.

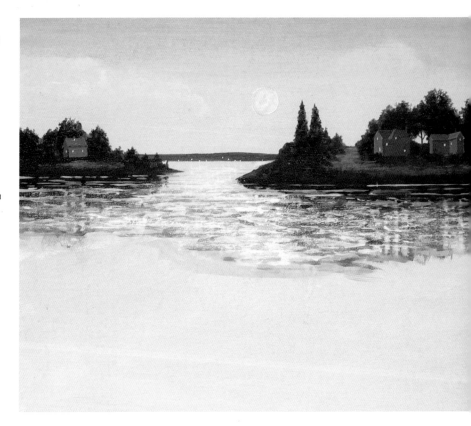

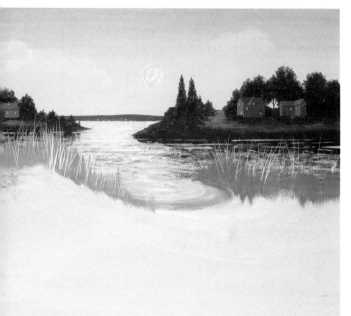

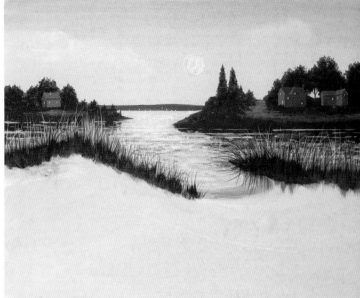

15 WORK ON THE BEACH

Bring the tracing paper back over the painting and use black transfer paper to retrace the edge of the beach where it meets the water. Mix Titanium White with a little Cobalt Blue and Mars Black to create a very light value to show where the dune rises on the left. Paint the wet curve of the beach with at least two values using Burnt Sienna, Mars Black and a little Titanium White.

Begin painting the grasses that sweep over the reflections on the right using Chromium Oxide Green, Mars Black and a little Titanium White to create a medium value of gray-green. Sweep the brushstrokes upward and then extend them with a no. 4 or 6 rigger. With a similar mixture of green, paint more grasses on the left side and extend them upward.

While that dries, mix Titanium White with a little Cobalt Blue and use a rigger to pull up some of the tiny grass tips that are moonlit. Don't worry about brushing over the beach; it will be repainted to cover the bottom of the grass so the grass will look like it's on the other side of the beach, giving a feeling of depth.

16 ADD GRASS IN SHADOW

The tips of the grasses may be catching the light of the moon, but most of the grass is in shadow with only a bit of light grass stroked in. Use combinations of green, purple or other colors of your choice to make a warm dark color. With a ½" (13mm) flat, pull it upward to create the first grass-like strokes. Then with a no. 4 or 6 rigger, repeat the strokes upward to create long strands of grass in the same color. The grass by the water is reflected onto the water near the beach. With each upward stroke, a downward stroke also needs to be made for the reflection on the water.

For the shadows on the beach, mix Cobalt Blue, Titanium White, Quinacridone Magenta and a little Mars Black. Use a 1" (25mm) flat to paint the areas that are more in shadow, creating a path of the light sand coming from the right.

Why Acrylic?

The beauty of acrylic paint is that additions can be made almost immediately. Whole areas can be repainted, more brushwork can be added—the possibilities are endless.

17 PAINT THE PATHWAY

Glaze over the light grasses with Hansa Yellow after they dry. Then mix a very dark color using Chromiun Oxide Green, Quinacridone Magenta and Phthalocyanine Blue. Stroke in more dark grasses with a ½" (13mm) flat, stippling in places to create little bushes among the grass. Use just the side of the brush to give the illusion that there are clumps of grass. Repaint the sand area near the water to cover the bottoms of the grass strokes. The beach area on the left can be redefined with a medium value of Cobalt Blue mixed with Quinacridone Magenta, Titanium White and a little Mars Black (a slightly lavender color). Because of the contrast, the pathway of light stands out and invites the viewer to enter this moonlit scene. Use a dry brush to blend the transition from light to dark.

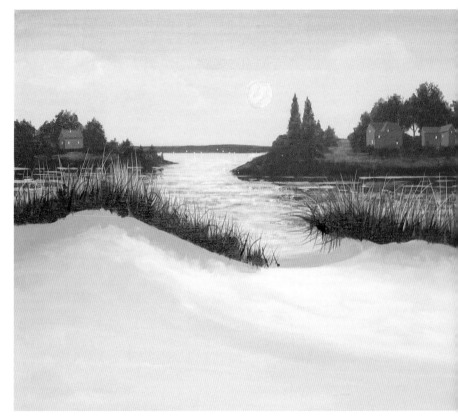

18 ADD MORE GRASS AND SPATTER THE BEACH

Add grass in the left foreground. Use a ½" (13mm) flat and paint it as you did the other grasses, but make it a larger clump. Use a no. 6 rigger to pull the blades of grass upward after each layer. When dry, use a smaller rigger to pull up pure Titanium White near the top of the dark grass. Dry the area and glaze it with Yellow Ochre or Hansa Yellow. Dry-brush the area where the grass meets the sand with a dark blue-lavender to soften the transition from hard edge to soft edge.

Lay your canvas flat on a table. You may want to put newspaper down to protect the surface. Create watery mixtures of paint with tints of gray, blue, yellow and white, and spatter the sandy area using a toothbrush (see page 40, step 5). Then use your finger to flip smaller spatters over the beach.

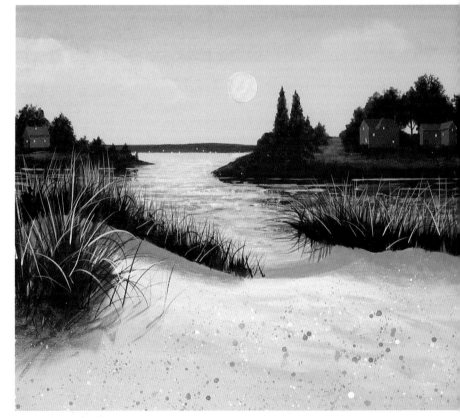

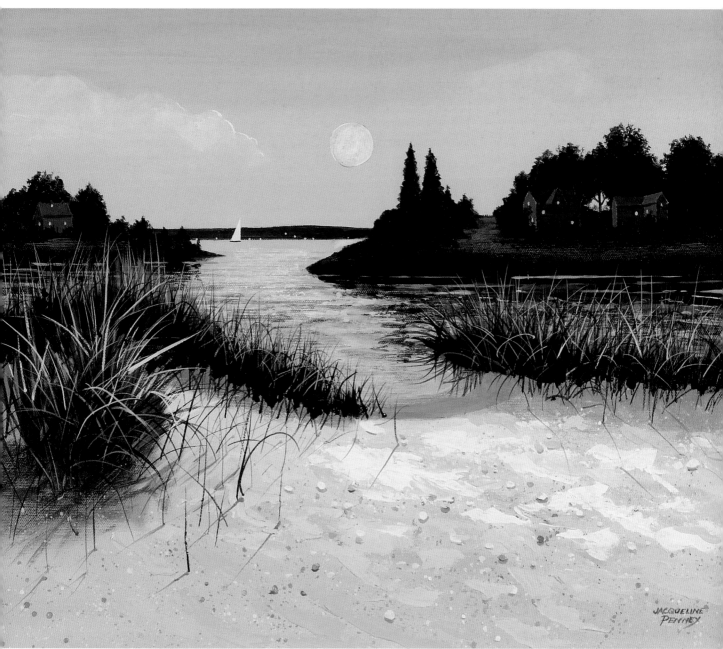

19 ADD THE FINISHING TOUCHES

With a no. 4 rigger, stroke random blades of grass near the large areas of grass. Use the edge of a ½" (13mm) flat to pull some of the dark green down onto the sand to create a smooth transition. Do this on both sides, and if any of the large grass clumps are covered, just add a few more blades of grass over the area as before. At the same time, make a tiny line from the base of the single blades of grass with a medium blue-gray to create shadows. Use the same blue-gray mixture and brush a smile-like stroke in front of some of the spatters on the beach with a no. 2 round. The little shadows give them weight.

Use a no. 4 rigger to paint a very tiny white line around the curve of the cloud. With a very dark mixture of green, Phthalocyanine Blue and Burnt Sienna, dab little bushes around the base of the houses with a no. 2 round. Creat the moonlit sailboat with masking tape (see page 58, step 12) and paint it with Titanium White mixed with a little Yellow Ochre or Raw Sienna to give it warmth.

AUGUST MOON
16" × 20" (41cm × 51cm)
Acrylic on canvas
Collection of Mary Ellen Fitzmaurice

CONCLUSION

When you learn how to paint, you learn how to see. You look at a road, a tree, a house, at everything, but do you really see? As you practice and take the time to look carefully, you will begin to see more of everything and be shocked at what you have missed. For instance, look at a tree. Where and what angle does the light come from? Is it backlit? Is the light coming from above, from the left or right? Look at the shadows and notice that the branches and leaves in the light are a little lighter than the branches underneath and away from the light. Maybe it's winter and barren. What is behind it, in front of it and next to it? If most trees, shrubs and grass are green in the summer, how do we tell them apart? It is because there are many varieties of greens. The color green can become warm by adding red; cool (blue), bright (yellow), light (white) and dark (black). Almost every color print is made up of three colors: cyan (blue), magenta (red) and yellow plus black. If the most delicate tint of pale beige can be made from these three colors, think of the variety of mixtures you can make with a palette full of colors.

When you learn how to mix color on your palette and apply it to canvas, you begin to really see color – color that surrounds you everywhere. For instance, what color is a mundane macadam road? It's not just gray that is made with black and white. Look at it on a sunny day, especially when there are shadows. You might see more than a gray road; you might be coaxed into seeing purple in the shadows and a yellow tint in the sunlight. On a cloudy day it will seem darker; and best of all, on a rainy day you will see wonderful reflections. Just don't do this while you are driving! Take a walk after it has rained and look at a puddle of water. Is it blue because it reflects the sky? Is there something behind it, such as a storefront, a batch of flowers, a tree? Look at the reflections. It's mesmerizing.

Take a good look at a house. Focus on the windows. What time of day is it? Are they black? Are there colors inside the windows? Do the windows reflect anything? Are there curtains or shades in the windows? How many mullions do the windows have? Look at everything and concentrate on what you are looking at. It's there—you just have to see it. What do you see when you look out of your window? It changes from hour to hour, day to day and season to season. It's a movie in very slow motion.

Learning how to see is the first step in learning how to draw or to paint. This book shows many examples of how to paint seascapes. But even though they are seascapes, they include trees, shrubs, grasses, rocks, sand, calm and moving water, clouds and even a moonlit sky.

The dialog for each step by step demonstration in this book is concise and not difficult to follow. Give painting a try. It will enrich your life!

ROUND ROBIN REGATTA
15" × 32" (38cm × 81cm)
Acrylic on canvas
Print available from Bentley Publishing Group

A group of sailors race around Robins Island, a small island in Peconic Bay, every Wednesday evening, and it inspired me to paint *Round Robin Regatta*. The palette knife painting was quickly executed in one setting.

This painting was also conceived in Maine on Monhegan Island, a lovely artist retreat.

MISTY ISLAND
22" × 28" (56cm × 71cm)
Acrylic on canvas
Print available from Bentley Publishing
Group

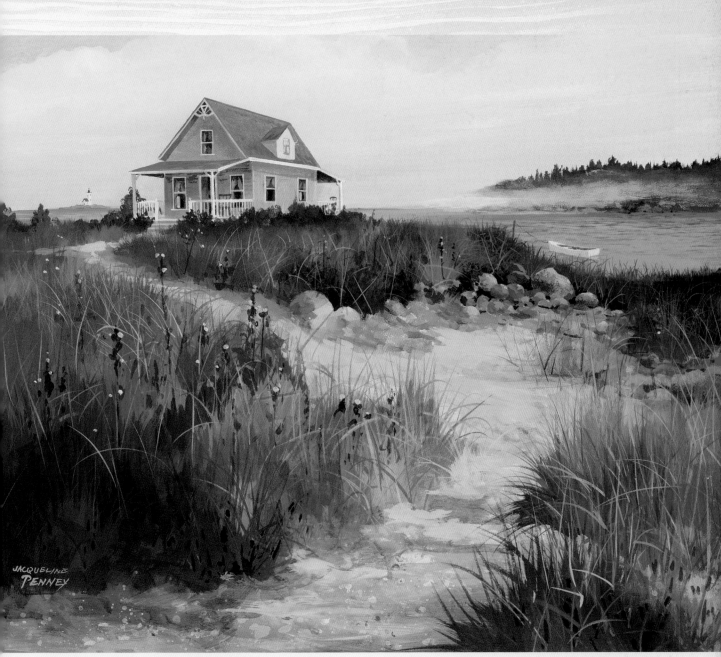

This house sits on a very tiny island in Maine and is very secluded. I added misty fog in the distance.

ISLAND RETREAT
22" × 28" (56cm × 71cm)
Acrylic on canvas
Print available from Bentley Publishing Group

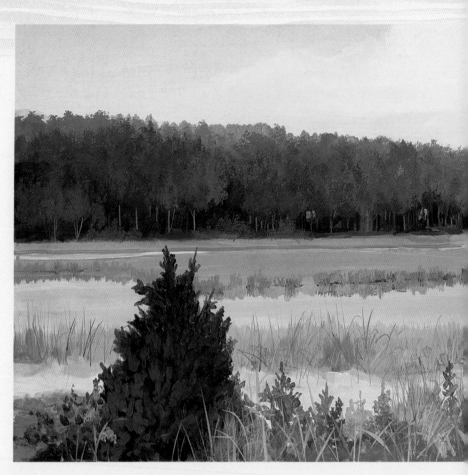

This elongated rectangle is perfect for a wide view such as these marshlands. The large bushes in the foreground push everything farther away.

BROAD WATER COVE
12" × 36" (30cm × 91cm)
Print available from Bentley Publishing Group

This painting of Cape Neddick/Nubble Lighthouse in Maine was simplified by omitting buildings and fences. The scene was made less austere by adding flowers and chairs in the foreground, and I would like to assume that the occupants went sailing.

GONE SAILING
22" × 28" (56cm × 71cm)
Acrylic on canvas
Collection of Richard A. Horstmann

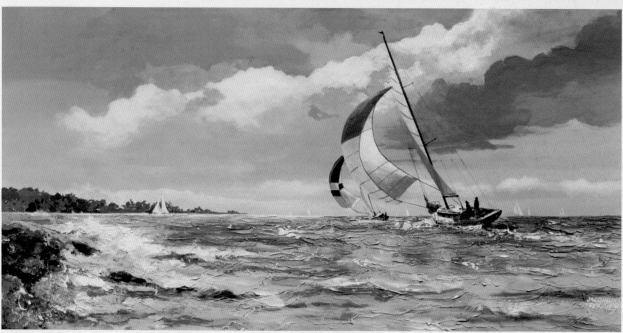

Most of *Before the Squall* was painted with a brush, but the water was done with a combination of brush and palette knife. There is no rule that says an artist cannot use several different techniques while executing a work of art. Wave action lends itself to palette knife techniques and adds excitement and depth to the painting.

BEFORE THE SQUALL
15" × 30" (38cm × 76cm)
Acrylic on canvas
Print available from Bentley Publishing Group

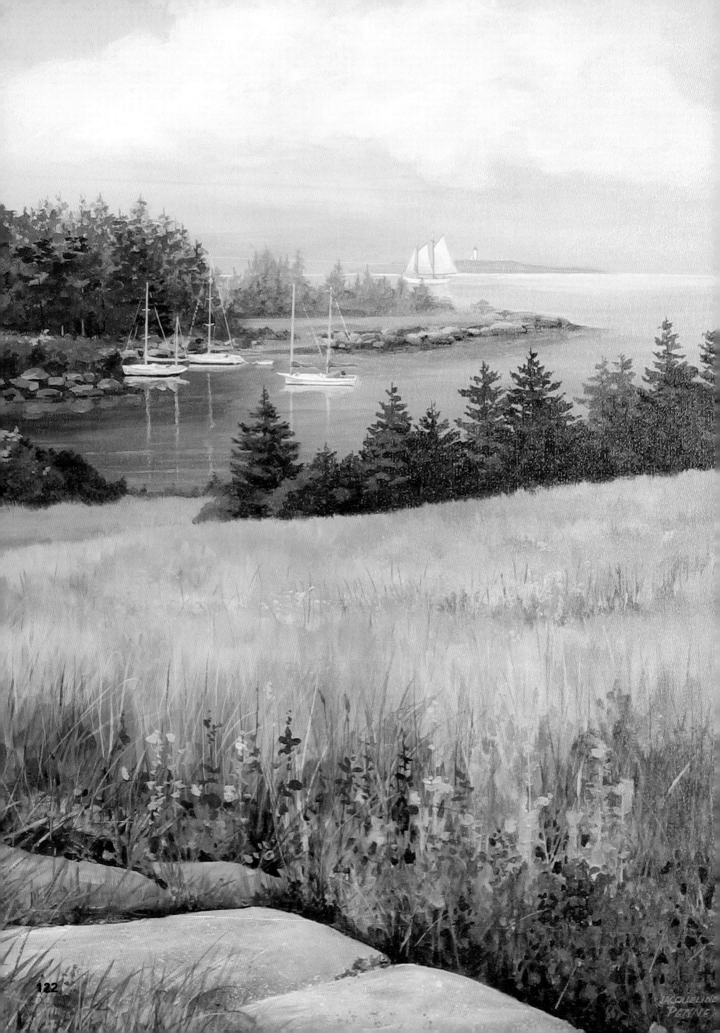

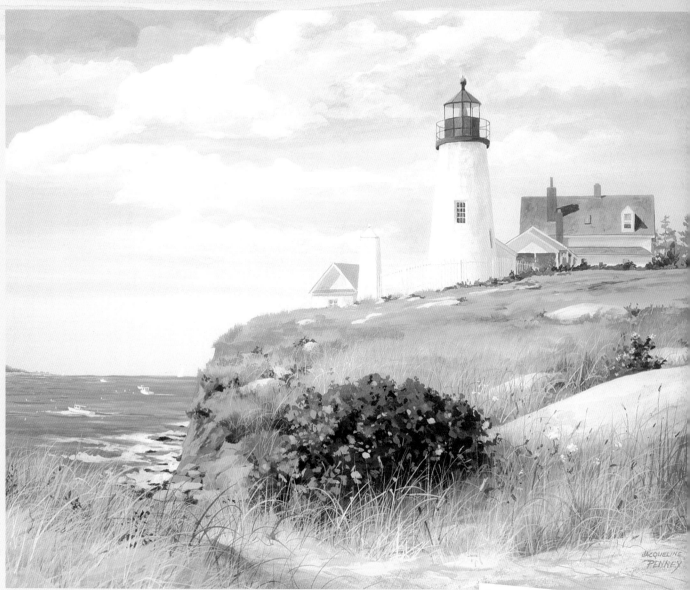

SAFE PASSAGE
22" × 28" (56cm × 71cm)
Acrylic on canvas
Collection of Kenneth & Deborah Seiferth

I made changes to this composition in order to show the water. I created a cliff and a pathway leading toward the water, bushes and a large rock to make the foreground more interesting, and I modified the house slightly. Even with all those changes it is still recognizable as Pemequid Point. I took "artistic liberty" and designed a painting, not the exact replica of a photograph.

Reference Photo

Photograph of Pemaquid Point Lighthouse, Pemaquid Point, Maine.

Sitting on top of this hill on a little island in Maine afforded this lovely view. I added a few sailboats and a distant lighthouse that really exists—but not right where I put it. The spruce trees grow abundantly and you can hear them whisper as the breeze blows through them.

DOWN EAST
28" × 22" (71cm × 56cm)
Acrylic on canvas
A version of this painting is available from Bentley Publishing Group

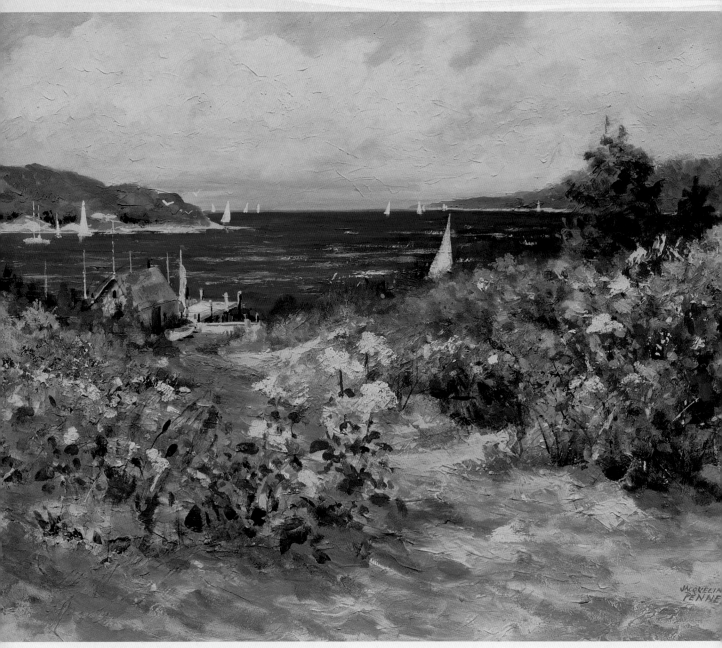

This painting was inspired by a visit to Monhegan Island in Maine, a well-known artist's colony, where you can walk the whole island in a day, climb the rocks and watch the whales and enjoy the beautiful Atlantic Ocean vistas. A palette knife was used to create much of this painting.

SUMMER SPLENDOR
22" × 28" (56cm × 71cm)
Acrylic on canvas
Print available from Bentley Publishing Group

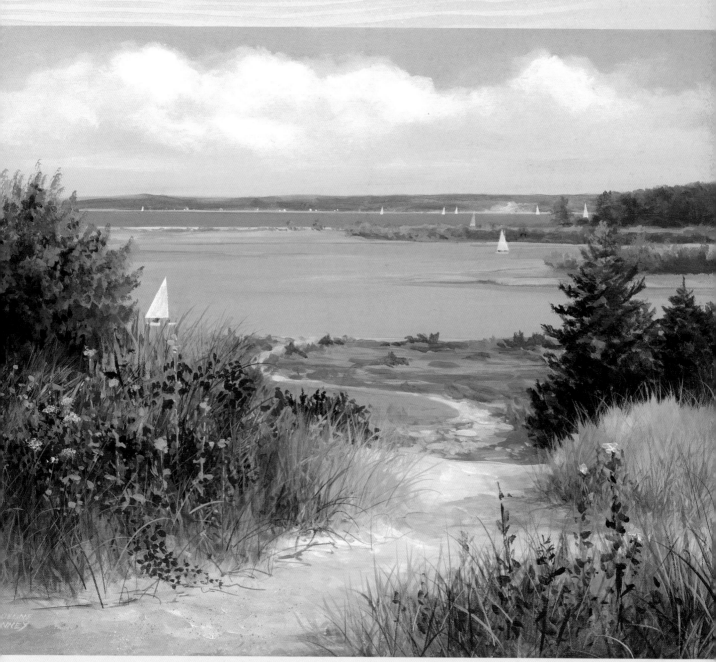

This scene is a view from my friend's backyard, but it had a
very large hothouse for plants blocking the view. I am familiar
with what was behind it, so I just eliminated the building and
created a meandering path toward the water and a couple of
sailboats to create this lovely panoramic scene.

ON HIGH GROUND
22" × 28" (56cm × 71cm)
Acrylic on canvas
Print available from Bentley Publishing Group

INDEX

THE BEST IN FINE ART INSTRUCTION AND INSPIRATION IS FROM NORTH LIGHT BOOKS!

This project book from acrylic aficionado Kerry Trout offers step-by-step instructions on how to paint cottages in a variety of architectural styles, from Victorian "gingerbread" houses and English Tudors, to Cape Cods and classic farmhouses. Two nostalgic village scenes take you back to simpler days of main streets lined with merchants, dress shops and tearooms. Dozens of quick mini-demonstrations teach you how to embellish your scenes with quaint details such as fountains, porch swings, lace curtains, picket fences and old-time lampposts. You'll also learn how to add the seasonal touches of fall foliage, spring flowers and winter snows. Full-color photos, traceable patterns and detailed materials lists make each scene easy to replicate. Bring the storybook cottages and towns of your dreams to life!

ISBN-13: 978-1-60061-133-9
ISBN-10: 1-60061-133-8
PAPERBACK, 128 PAGES, #Z2277

Through the masterful guidance and breathtaking work of award-winning artist Mark Christopher Weber, you'll see how simplicity is the key to painting thick, exuberant strokes successfully. Step-by-step instructions teach you five basic strokes that comprise bold paintings. Then you'll practice the bold strokes in a series of exercises designed to help you paint with confidence and decisiveness. By limiting the number of strokes you use, you'll acquire the necessary skills to create the energetic, dramatic brushwork you've always admired. A range of subjects is featured so you can learn to paint all kinds of textures, from clouds and water to skin, fur, metal and more. The tips and techniques provided will help you avoid common mistakes and pitfalls so you can paint better than you ever have before.

ISBN-13: 978-1-60061-067-7
ISBN-10: 1-60061-067-6
HARDCOVER, 144 PAGES, #Z1802

In this gorgeously illustrated book, Bob Rohm shows you how to see the world from a painterly perspective and translate it into expressive, poetic paintings that elicit an emotional response from your viewer. Learn to clearly illustrate how to choreograph color, value, composition, texture and other fundamental elements to achieve mood and emotion in your landscapes. Features nine step-by-step demonstrations in oil, pastel and acrylic.

ISBN 13: 978-1-58180-998-5
ISBN 10: 1-58180-998-0
HARDCOVER, 144 PAGES, #Z0984

These and other fine North Light Books are available from your local bookstore, art supply store, online supplier or visit our website at www.artistsnetwork.com.